The Campus History Series

TENNESSEE
TECHNOLOGICAL
UNIVERSITY

MANCIL JOHNSON AND W. CALVIN DICKINSON

D1211276

The Campus History Series

TENNESSEE TECHNOLOGICAL UNIVERSITY

MANCIL JOHNSON AND W. CALVIN DICKINSON

ARCADIA
PUBLISHING

Copyright © 2002 by Mancil Johnson and W. Calvin Dickinson
ISBN 978-0-7385-1424-6

Published by Arcadia Publishing
Charleston, South Carolina

Printed in the United States of America

Library of Congress Catalog Card Number: 2002100884

For all general information contact Arcadia Publishing at:
Telephone 843-853-2070
Fax 843-853-0044
E-mail sales@arcadiapublishing.com
For customer service and orders:
Toll-Free 1-888-313-2665

Visit us on the Internet at www.arcadiapublishing.com

CONTENTS

ACKNOWLEDGMENTS

The authors would like to express our deep appreciation for the assistance and encouragement of many people. We wish to especially thank Mrs. Christine Spivey Jones, who is the Special Collections Librarian at Tech, a Tech Alumna, and a living encyclopedia of information about both Tennessee Tech University and the Upper Cumberland Region.

We are grateful for the assistance, advice, and professionalism of the Photographic Services Division—Dean Carothers, John Lucas, Jeannine Lynn, Kimberly Nash, Brenda Taylor, and Samantha Davis.

We would like to thank the Alumni Affairs Office and Mr. Lee Wray for their support. Last, but by no means least, we are most appreciative to Ms. Pat McGee for her editorial expertise.

INTRODUCTION

The genesis of the university was in 1909, with the foundation of a private college called the University of Dixie. Dixie was an institution created by the Church of Christ to serve the southeast region. The parent of Dixie College was the Broad Street Church of Christ in Cookeville, Tennessee, and the primary leader of the church in the enterprise was prominent Cookeville businessman, Jere Whitson.

The "university" never became a college, but acted as a primary school. The school never attracted students from the southeast region, but only from the immediate Tennessee area. The school never secured adequate operating funds, despite hiring an agent to tour the south recruiting students and funds. Dixie College opened in 1912 in temporary quarters, with W.B. Boyd as president and with a faculty of nine. A 3-story brick building, with dimensions of 100 by 60 feet, was eventually completed in the center of the 18-acre campus.

In 1915, Cookeville leaders offered Dixie College to the state. Local legislators sponsored a bill in the legislature, and Gov. Thomas Rye supported and signed it. An outcry from the University of Tennessee and other public colleges in the state, as well as from many high schools, did not deter the organization of Tennessee Polytechnic Institute in Cookeville. The state assumed ownership of the one building and several acres of Dixie College to operate the institute. For many years, TPI acted as a high school rather than a college because no public high school existed in the area.

Thomas Early of Mississippi was named the first president of the new state school, and he employed 11 faculty members to teach 250 students in the first academic year, 1916–1917. Most of the students were males, and all but 11 were elementary or high school students. In 1925 TPI enrolled 107 high school students and 265 college level students, and in 1927 the school awarded its first college degrees and closed the high school program. It developed curriculums in engineering and education and attracted an increasing number of students, mainly from the immediate area surrounding Cookeville. Quentin M. Smith (serving from 1920 to 1938) and James M. Smith (serving from 1938 to 1940) were the two presidents after Early. Austin Wheeler Smith was the history professor and dean/registrar at this time.

These three men were the namesakes of the later dormitory complex called "Smith Quad." Q.M. Smith's administration was important in developing TPI as a college. He persuaded the Board of Education to grant four-year college status in 1927, he developed intercollegiate athletics at the school, and he recruited quality faculty members, many with doctoral degrees. Two faculty members who would bring fame to themselves and the school were P.V. "Putty"

Overall as a football, baseball, and basketball coach, and Charles Bryan as an instructor and composer in music. Smith was also the first of two "building" presidents. During his presidency construction of a dormitory for women (1921), a president's home (1927), a gymnasium (1929), a science building (1929), and an engineering building (1931) took place.

Tech's enrollment reached about 1,000 by 1930, but the numbers dropped into the 700s during the Depression. Most students came from farm families, but most studied for teaching careers at the school. Costs at the school in the 1930s were $10 to $15 for registration fees, $12 for a dormitory room, and $42 for food.

In 1940, Everett Derryberry was named president of TPI. He would prove to be more important to the history of the school than any other individual. An honor graduate of the University of Tennessee and a Rhodes scholar, he possessed a powerful personality and enormous energy. Using warm personal relations with governors and legislators, he built the campus of the school in an attractive neo-Georgian style that still prevails. Most of the buildings on the campus were either built or remodeled during his presidency.

He developed the program of the school, adding master's degrees in the 1950s and a Ph.D. in engineering in 1965. He persuaded the state government to bestow the title Tennessee Technological University on the school in 1965. The quality of the faculty improved, as exhibited by numerous publications from the new instructors with doctoral degrees that made up the expanded faculty.

Student numbers and student activities expanded greatly during Derryberry's presidency. By 1970, the student body had reached 6,000 and majors existed in engineering and business, as well as arts and sciences, education, and agriculture/home economics. A new university center housed eating and meeting facilities for students, and the development of ROTC, fraternities and sororities, *The Oracle* newspaper, and intercollegiate and intramural sports provided extracurricular opportunities for the enlarged student body.

"Dammit" and the Golden Eagle became the symbols of the school for the student body. John's and Ralph's were student hangouts during this period. After Derryberry's retirement in 1974, four presidents served the university. Slower growth in the student body and less money in the state budget have resulted in less spectacular development in the last 25 years. Dr. Arliss Roaden led the school toward quality education and national recognition between 1974 and 1985, attempting to position the school among the best in the country. Dr. Wallace Prescott, who had been associated with the school since his first year as an engineering student in 1946, became interim president on Roaden's departure. He had been a faculty member, dean of the faculty, and vice president at Tech before his presidency.

In 1988, Dr. Angelo Volpe became president, serving until his retirement in 2000. Dr. Robert Bell, former dean of the College of Business, became president in 2000. During this period after 1974, the Hooper-Eblen Athletic Center, the Charles Bryan Music/Art Building, the university library, and the fitness center were completed. New degrees were added, a nursing program was initiated, the Appalachian Craft Center was built, and four Centers of Excellence expanded the research facilities of the school. Over the years, the faculty has expanded in numbers and in areas of research and publication. Dr. Krishna Kumar, a faculty member in the physics department, was world-renowned in his research. Dr. Robert Jager, resident composer in the music department, had compositions commissioned and performed the world over. Sally Crain-Jager and Chris Koczwara in art achieved renown in that field.

Today the university is recognized as one of the best schools in the state and the region by residents and by educational publications and agencies. Student activities in the last 30 years have also expanded. The student body has grown to about 8,000. By the 1980s, the cost of education at Tech had increased to about $4,000 annually, still a low price by national standards. Tech students were brighter than most other Tennessee college students were at this time, and they won some prestigious awards for graduate study. The school's athletic teams brought home many trophies. Men's football, basketball, and tennis teams won the Ohio Valley Conference, and the women's basketball team and the Tech Rifle team won national honors.

One

DIXIE COLLEGE
1911–1915

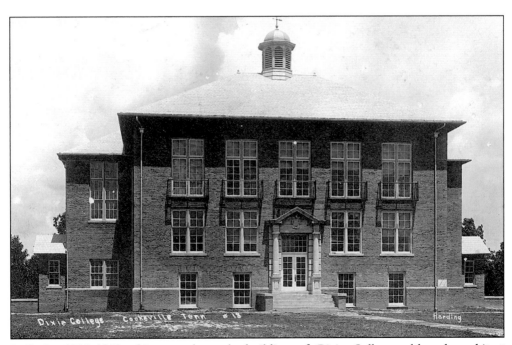

Built in 1911–1912, this was the only building of Dixie College, although architect William B. Stetner had drawn a complete campus sketch. All of the functions of the school occurred in this main building. Dixie College opened in 1912 and closed in 1915.

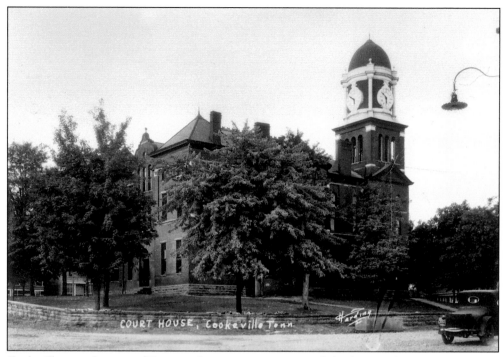

Cookeville was the seat of Putnam County government and the home of Dixie College. The Romanesque Revival courthouse was constructed in 1900 after the previous one was destroyed by fire.

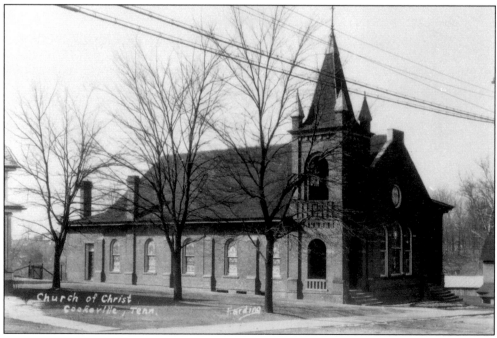

Members of the Broad Street Church of Christ, housed in this Gothic Revival structure, chartered Dixie College in 1909. The church financed the school as a secondary education institution to educate the young people of the region.

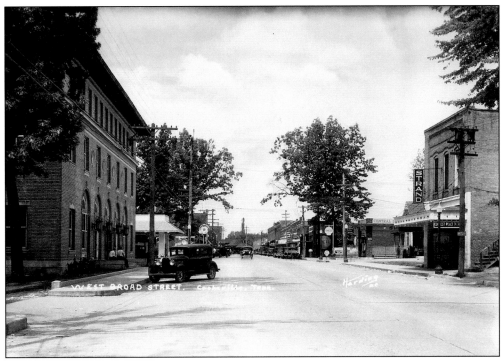

Cookeville Post Office, on the left, was built on West Broad Street in Renaissance Revival style between 1913 and 1915 and was a popular place with Dixie College students. Equally popular was the Strand Theater across the street. Built about 1915, the Strand was the first permanent movie theater in Cookeville.

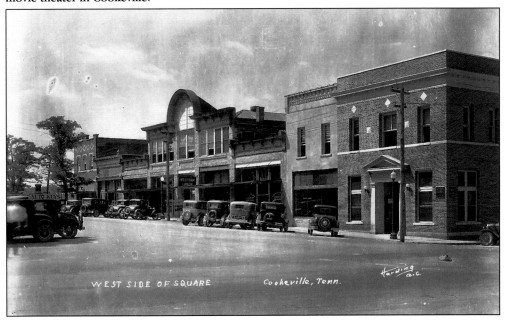

The First National Bank, on the right, and the Arcade dominated the west side of Courthouse Square. The Arcade, a shopping "mall" built in 1913, was one of only three such structures built in Tennessee.

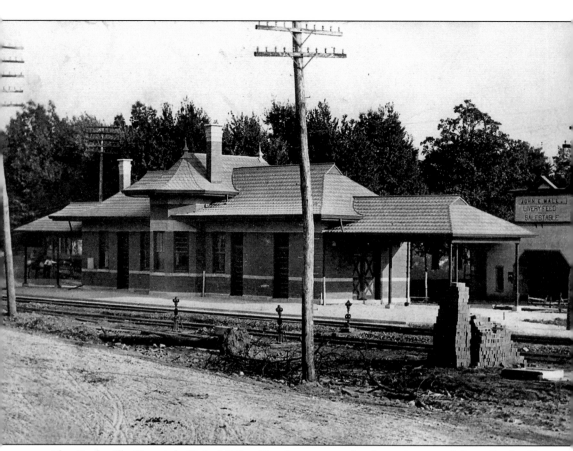

The Cookeville Depot, built in 1909, offered transportation by train to and from Cookeville for students. Cookeville residents used the Tennessee Central Railroad trains to shop and attend schools in Nashville. The depot had four rooms—a baggage room, a ticket office, and white and "colored" waiting rooms. Built with a flared-eaves roof, this building incorporates the style of structure called "pagoda."

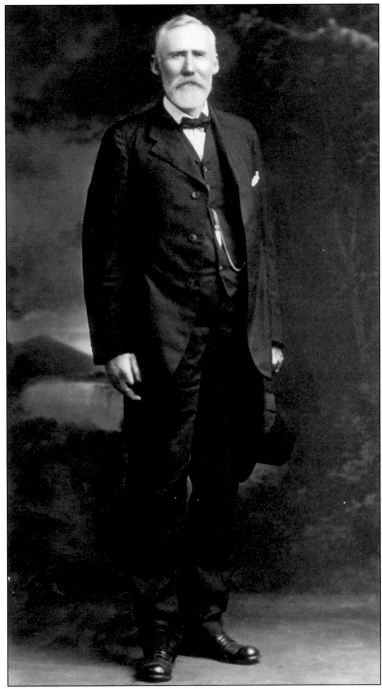

Jeremiah Whitson is considered the founder of Dixie College. Born in 1853, Whitson made Cookeville his home in 1890. He opened the Whitson Hardware Company on the square and acquired great wealth in this business as well as in real estate, farming, and banking. As an elder in the Broad Street Church of Christ, Whitson led the campaign to open Dixie College. He donated the land for the school and served as chair of the board during the school's lifetime. Whitson, pictured here in later life, died in 1928.

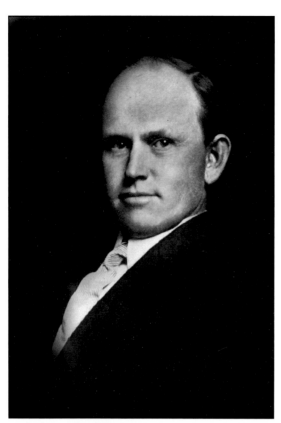

Willis Baxter Boyd was the first president of Dixie College, from 1912–1914. A graduate from Burritt College in Van Buren County, he attended the University of Chicago for graduate study. Boyd taught English literature and moral sciences at Dixie College.

This large classroom in the main building at Dixie College featured a stamped metal ceiling and stucco walls. Desks were metal with wooden seats and tops. The pianos indicate that music was sometimes taught in this classroom.

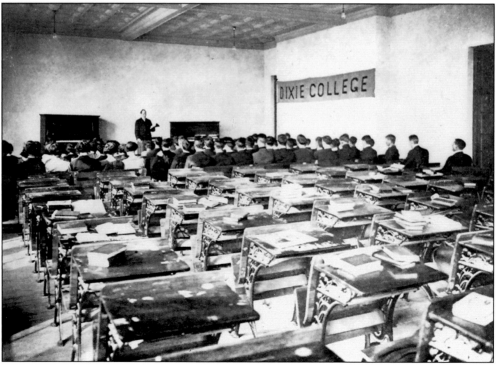

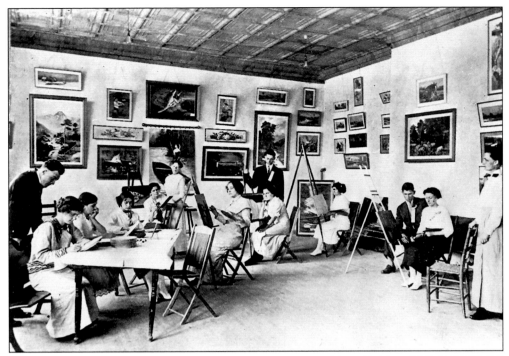

This photo is of Miss Fannie Kuykendall's art classroom at Dixie College. During commencement week, the students had their annual art exhibit in the studio. The 1915 *Dixie Derrick*, a student publication, listed 17 students in her art class.

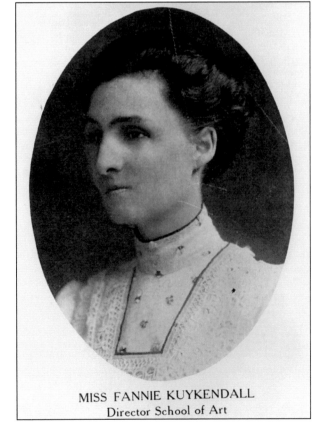

MISS FANNIE KUYKENDALL
Director School of Art

Miss Fannie Kuykendall was the director of the School of Art as well as the only art instructor. She graduated from Burritt College with a Bachelor of Arts degree.

The photograph above shows the Dixie College faculty of 1913–1914. They are, from left to right, (front row) Donald Russell (coach) and John E. Cunn (history and moral philosophy); (second row) Daisy Reagan (music), H.D. Franklin (harmony and theory of music), Willis Baxter Boyd (president and instructor of English and literature), Fannie Kuykendall (art), and Edna Gertrude Mason; (third row) Samuel Nicholas Jared (math and physical sciences), and John E. Dunn (history).

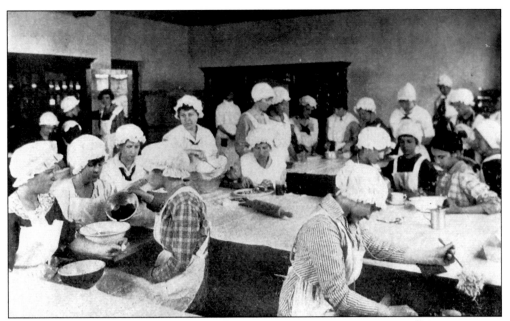

This domestic science class of 1915 illustrates a popular course of study for female students. In addition to cooking, domestic science included sewing, home nursing, and house furnishing. All the students in the class are identified in the *Dixie Derrick*.

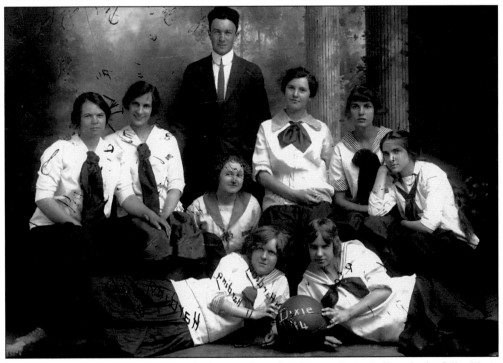

As this photo of the women's basketball team of 1914 indicates, Dixie College had a full athletic program of football, baseball, and men and women's basketball. In 1914, these "Dixie Co-eds" played 3 games, winning only the game with the "Cumberland Co-eds." The men's basketball team played 11 games in 1914, winning 3.

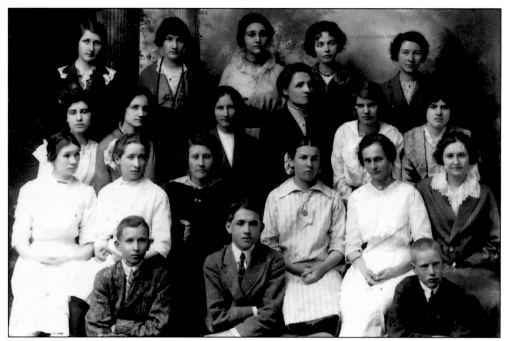

Miss Kuykendall's art class in 1914 included the 19 students above. Miss Kuykendall is fourth from the left on the third row.

The *Dixie Derrick* was the school's quarterly student publication consisting of about two-dozen pages of typeset plus photos on slick paper with soft covers. Student subscription was 50¢ per year. This photo of editor-in-chief Robert Elrod and the editorial staff appeared in 1914.

Two

Tennessee
Polytechnic Institute
1915–1940

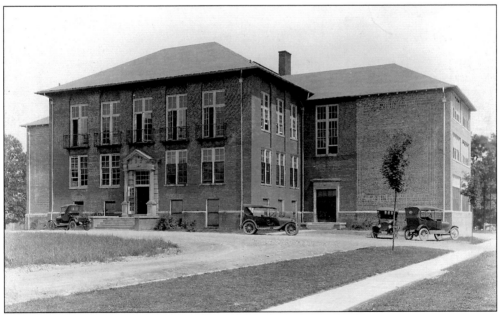

In 1914, with finances and student enrollment declining, Dixie College representatives discussed giving the school to the state. In 1915 Tennessee accepted the campus as a gift, establishing Tennessee Polytechnic Institute (TPI). Additions were constructed to extend the east and west wings of the main building, now referred to as the Administration Building. This building still housed offices, classrooms, and the library.

TPI's first president was Thomas Alva Early, who held this position from 1916 to 1920. A native of Mississippi, Early graduated from the University of Georgia, probably with a degree in agriculture. He was a county school superintendent in Mississippi and then worked with the Agricultural Extension Department of the University of Georgia. Early lobbied the Tennessee Board of Education to become TPI president. J.M. Hatfield, superintendent of Putnam County Schools, supported Early's nomination. No other candidates for the position are known. In 1920, Early resigned after controversies with the state board and with his faculty.

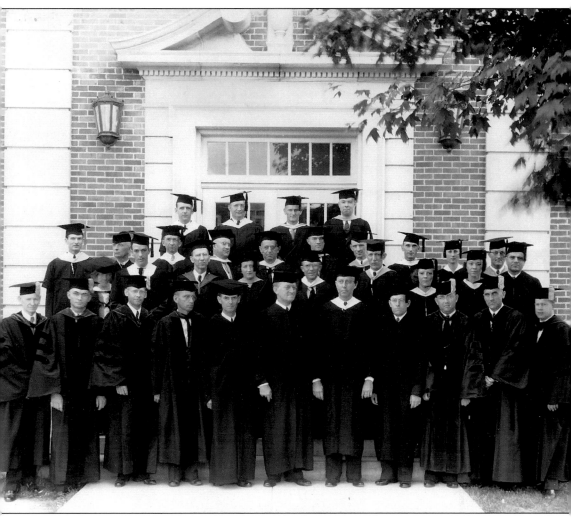

TPI had 12 faculty members in 1916. By 1934, Q.M. Smith, TPI's second president, had tripled the number of faculty, including teachers with doctoral degrees. Smith is number seven from the left on the first row. Note the seven robes indicating doctorates on the ends of the first row. This photo was taken in front of the Home Economics Building.

The Science Building, constructed in 1929, was the first classroom structure built at TPI. It housed the agriculture, biology, chemistry, and education programs. Later the structure was named the T.J. Farr Building in memory of the director of the School of Education. The building now houses classrooms and offices of the College of Education.

The Industrial Arts Building, designed by R.H. Hunt and Co. of Chattanooga in Georgian Revival style, was built in 1931. It was originally called the Engineering Building and was then renamed Henderson Hall in memory of J.M. Henderson, the first dean of the College of Engineering. Beginning in 1970, it housed the English, history, and political science departments. This building is now listed on the National Register of Historic Buildings.

President Q.M. Smith assembled a notable and long-serving faculty, some of whom are pictured with him in this 1926 photo. Smith graduated from Peabody College, receiving an M.A. in 1927. Before becoming TPI president in 1920, he was principal of Central High in Cleveland, Tennessee. In 1938, he left Tech to become president of Middle Tennessee State Teacher's College in Murfreesboro.

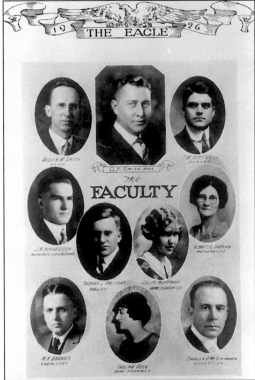

This photo shows the "Shakespearean Players," a group of 1926 TPI faculty who performed *Twelfth Night.* Charles McClannahan, who taught education courses and is one of the men in the photograph, directed the production.

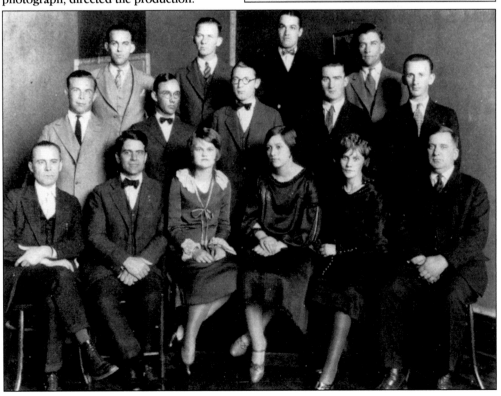

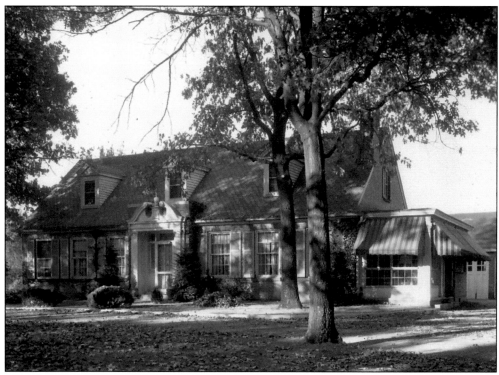

The first president's home, erected in 1927 at the corner of Ninth Street and Dixie, was remodeled and enlarged in 1942. It was demolished in the 1950s and replaced by Dixie Quad.

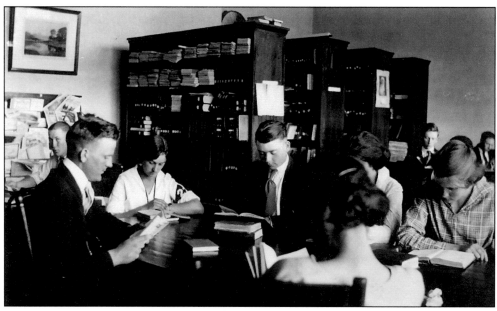

The first library was in the Administration Building. The weight of the books finally endangered the safety of the floors, and a new library was built in 1949. Note the formal dress of the students, which was normal attire for attending school.

James Millard Smith replaced Q.M. Smith as TPI president in 1938. A native of Tennessee, J.M. Smith earned his B.A. degree at West Tennessee State Teachers College in Memphis and his M.A. from Peabody College. From 1933 to 1937, he was dean at West Tennessee, the first TPI president to hold a college administration position before coming to Tech. In 1938, he was appointed to the position of Tennessee Commissioner of Education. He served as president of TPI from 1938 to 1940, resigning to return to Memphis. In 1946, he became president of West Tennessee State College. Tech was accredited by the Southern Association of Colleges and Universities during Smith's tenure.

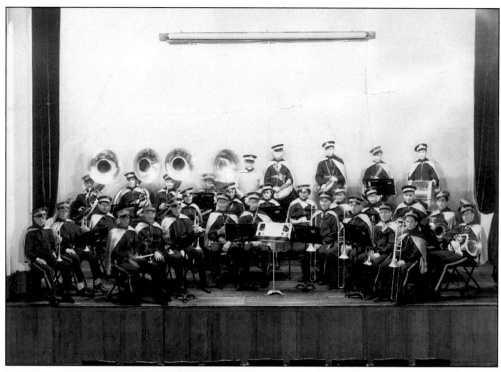

Charles Faulkner Bryan directed the TPI band in 1938. In 1921, an auditorium was added to the Administration Building. This band is pictured on the auditorium's stage.

Charles Faulkner Bryan joined the Tech faculty in 1935. He was the only faculty member in the music program. A native of McMinnville, Tennessee, Bryan graduated from the Nashville Conservatory of Music in 1934. At TPI, Bryan began his study of folk music, from which his later musical themes evolved. In 1939, Bryan left TPI to attend Peabody College. He studied with Paul Hindemith at Yale in 1945–1946 and he wrote *The Bell Witch* folk cantata with funding from a Guggenheim Award. A 1949 Carnegie grant resulted in *Singing Billy*, a folk opera that is one of his most important works.

J. Robert Bradley was the first African-American student to attend TPI, although he was never officially enrolled because of the Tennessee policy of racial segregation. In 1938, Bradley moved to Cookeville. Mrs. Charles Bryan taught him to read and write during the day and Charles Bryan taught him music at night. Bradley later studied music in New York and worked with the National Baptist Convention, singing in Europe and South America.

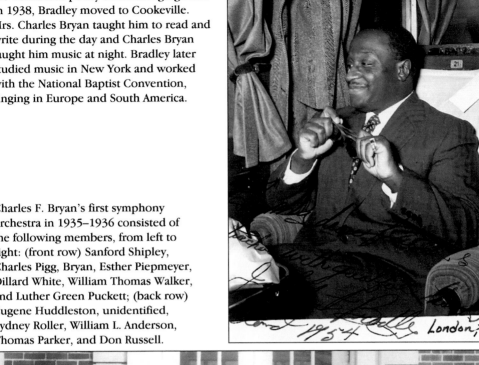

Charles F. Bryan's first symphony orchestra in 1935–1936 consisted of the following members, from left to right: (front row) Sanford Shipley, Charles Pigg, Bryan, Esther Piepmeyer, Dillard White, William Thomas Walker, and Luther Green Puckett; (back row) Eugene Huddleston, unidentified, Sydney Roller, William L. Anderson, Thomas Parker, and Don Russell.

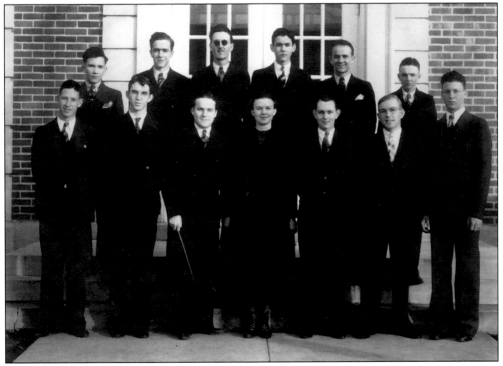

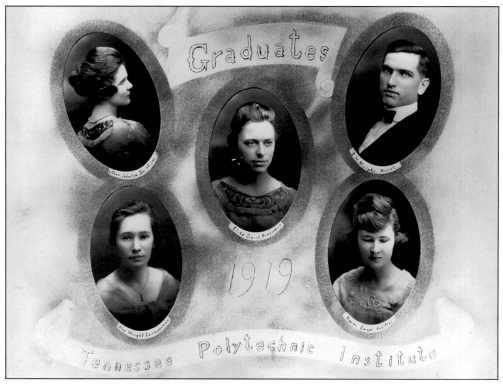

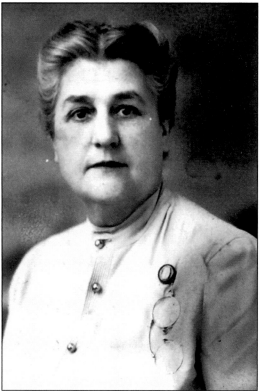

Nine students received high school diplomas in TPI's first graduating class in 1917. In 1919, 17 students graduated. Pictured here are the 1919 class officers.

Beulah Betty McDonald was the first student to earn a college degree at TPI. In 1918, she received a two-year diploma with a major in English. Nine other students received two-year degrees that same year.

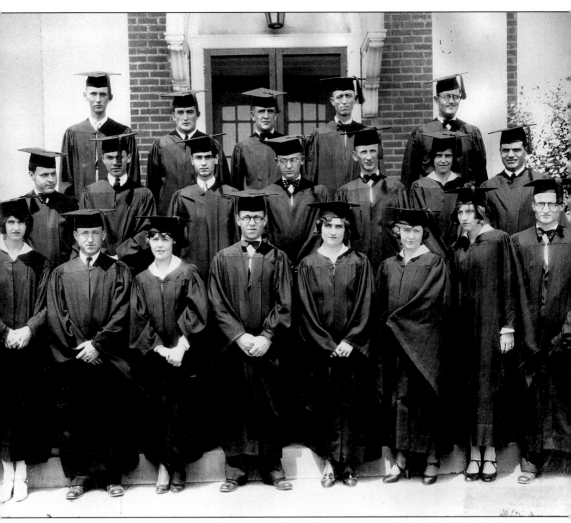

The class of 1929 received the first four-year college degrees. Leonard Crawford, fourth from the left on the front row, later served as the director of placement at Tech. Hazel Wall, fifth from the left, later served as the secretary to the president atTech. James Buck, first on the third row, was a librarian at Tech, and Tom Kittrell, seventh from the left on the second row, was the bursar at Tech.

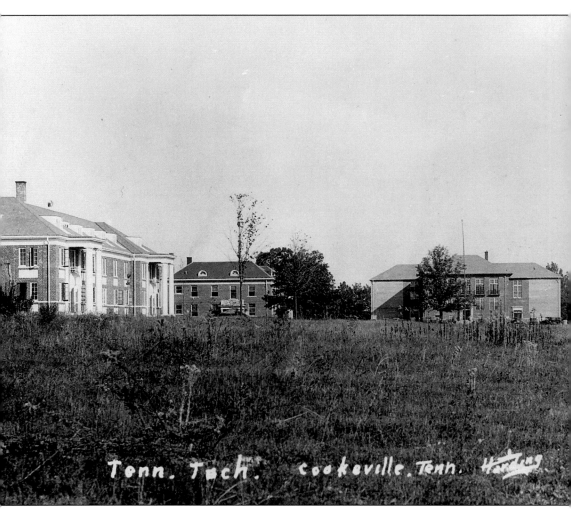

Tech's growth in enrollment in the 1920s required additional buildings. Shown here are the enlarged Administration Building on the right, West Hall dormitory in the center, and South Hall women's dormitory, built in 1921, on the left.

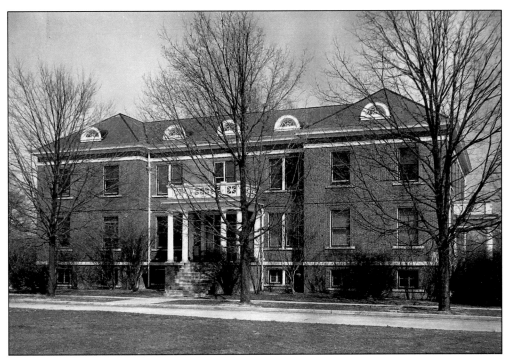

East Hall men's dormitory was erected in 1916 to house 50 students. A modern facility, it was equipped with bathrooms, electric lights, and steam heat. A kitchen and dining hall were located in the basement. In 1957 it was converted into a classroom building.

West Hall women's dormitory, built with East Hall in 1916, was remodeled in 1943 and two wings were added. In 1956 it was converted into a classroom building. In 1916 rent on a dormitory room with furniture, heat, water, and lights was $2 per month.

This gymnasium, Tech's first, was erected in 1929. It served the school for 20 years. The building had a basketball court, bleachers, and electric lights.

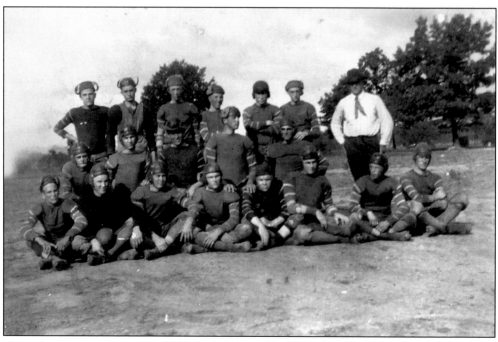

Shown here are members of the 1919 football team. The TPI Bulletin for that year proclaimed that "organized athletics is believed to contribute greatly to a vigorous student life, and is encouraged by the faculty, so far as it does not interfere with school work."

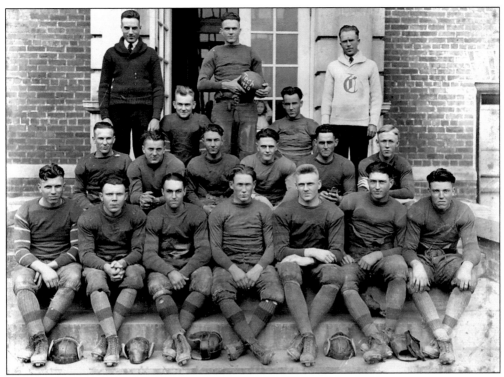

Pictured here is the football team of 1920. Note the lack of identification insignia on the uniforms, the lack of pads, the heavy cleats on the shoes, and the leather helmets.

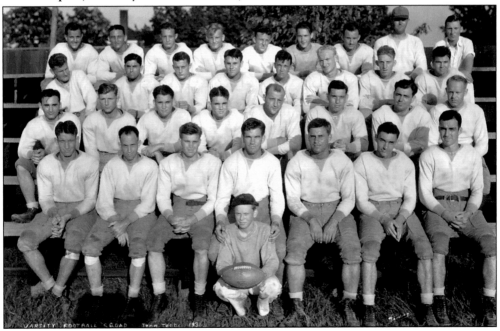

The 1931 football team scored a total of 212 points to their opponent's 46 points. The team won six of nine games and tied one. Sewanee and Bethel defeated Tech that year. Alfred Gill was the team captain. Coach P.V. "Putty" Overall is on the top row wearing the hat.

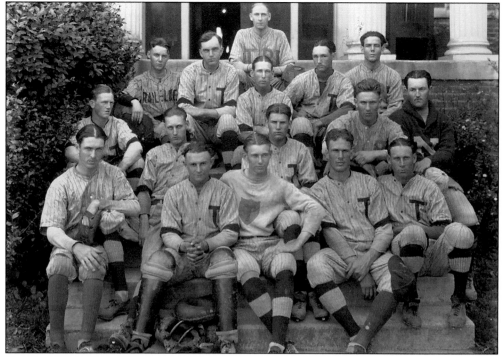

This 1924 Tech baseball team was also coached by Putty Overall, who is pictured here in the black sweater on the right. Overall came to TPI in 1923, taught agriculture, and coached football, basketball, and baseball.

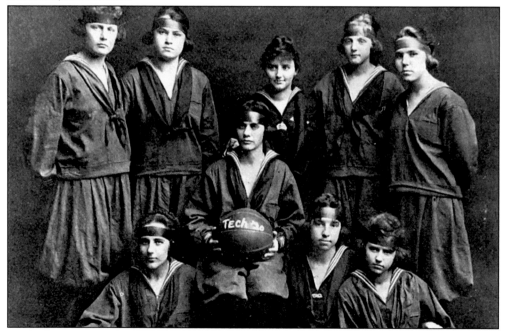

The women's basketball team of 1920, pictured above, included Inez Cunningham, Winnie Jared, Katherine Judd, Medora Maddux, Elsie Little, Virginia Vaden, Juanita Comstock, Dollie Smith, and Coach Katherine Smith. Note that the modest, feminine uniforms included headbands.

34

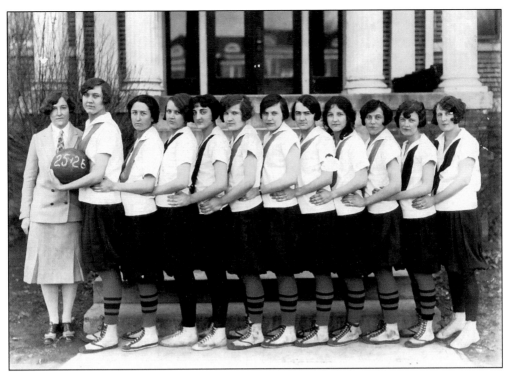

The uniforms of the 1925–1926 women's basketball team shows some variations. Earlier teams had to furnish their own uniforms, which may account for the differences. Coach Carolyn McClanahan is on the far left.

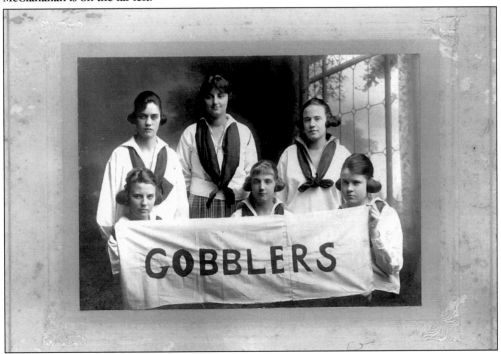

The Tech "Gobblers" appeared in the 1920 *Dynamo*.

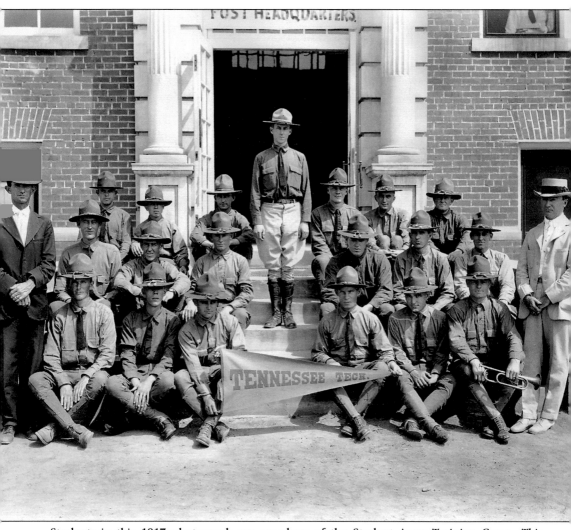

Students in this 1917 photograph are members of the Student Army Training Corps. This program, a predecessor of R.O.T.C., lasted only a year or so. This group was photographed in the front door of the Administration Building.

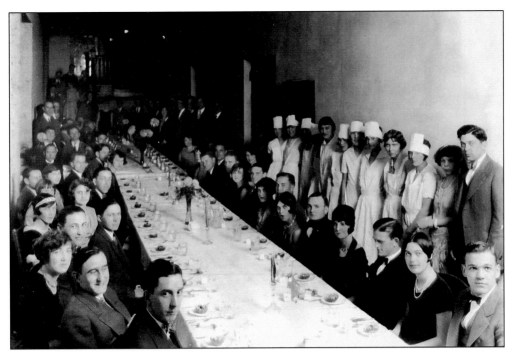

This *c*. 1925 photograph of a banquet was probably made in the basement dining hall of the Administration Building.

The TPI debate team in 1923 is shown in this image. The man seated third from the left was C.B. Richmond, a native of England and the team sponsor.

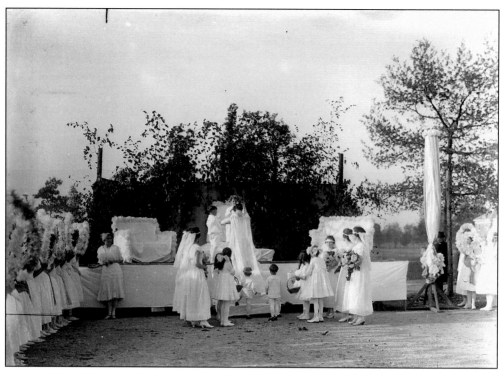

In 1918 TPI celebrated May Day with the crowning of a queen (above) and the presentation of her court (below). This may have been the first May Day celebration, but it became an annual event, continuing into the 1960s. The Tech wagon provided a platform for the stage. These photos were made from glass negatives in the TTU Archives.

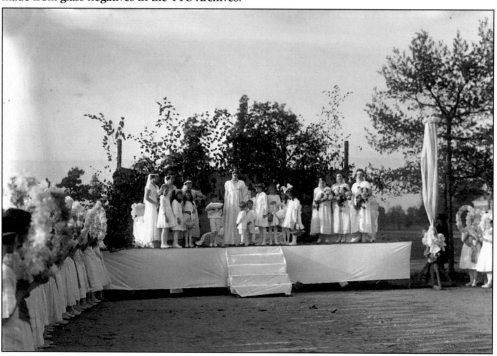

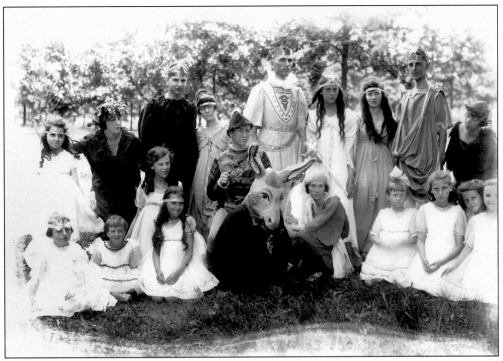

The cast of *A Midsummer Night's Dream*, a part of the 1918 May Day celebration, pose in the photograph above.

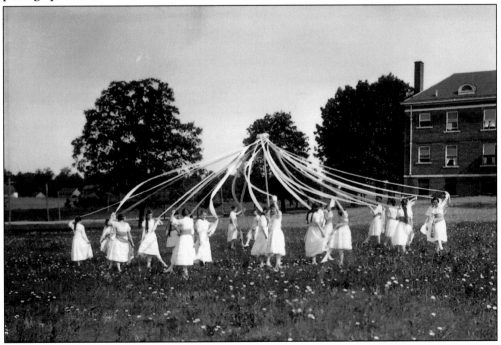

The maypole dance in 1918 was performed on the quad between East and West Halls. Note the wild daisies. The May Day Festival represented and celebrated the coming of spring and the end of the school year.

These three unidentified TPI students, pleased with themselves and their school, posed for a portrait at the Harding Studio on West Broad Street. Many of the photos in this book came from the Harding Studio.

Three

THE DERRYBERRY YEARS 1940–1974

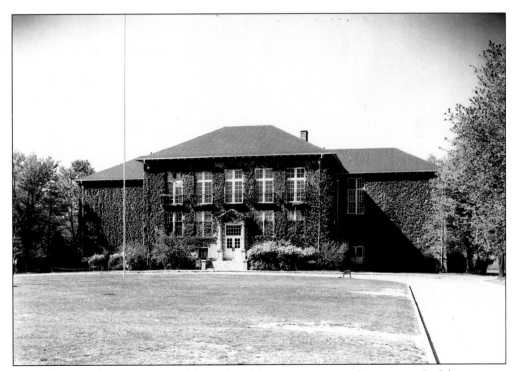

By 1940, the Administration Building, the oldest structure on the campus, had become an ivy-covered hall, symbolic of academic institutions. An auditorium was added to the rear of the building in 1922–1923.

Gov. Prentiss Cooper chose William Everett Derryberry as president of TPI in 1940. He graduated Summa Cum Laude from the University of Tennessee, and he earned a second Bachelors Degree and an M.A. from Oxford University as a Rhodes scholar. Everett married Joan Pitt-Rew of Devonshire, England, who came to Tech with him. Derryberry served as TPI's president until 1974, the longest serving chief executive of the institution. During his administration, Tech built most of the campus structures, added the master's and doctorate programs, became Tennessee Technological University, and increased student enrollment to almost 6,400.

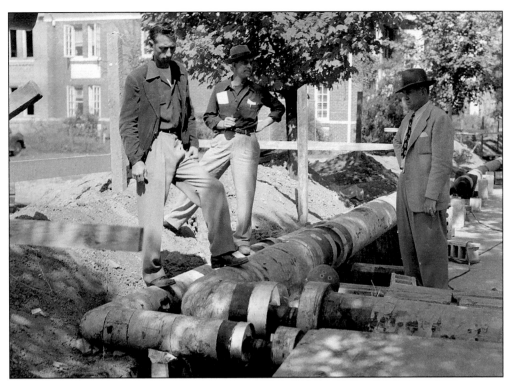

President Derryberry's avocation was architecture, and building the campus was his delight. He used the quadrangle design that he had observed in Oxford, constructing buildings around open quads. He continued the use of the neo-Georgian and neo-classical styles of the older campus buildings. Classroom buildings, dormitories, athletic facilities, an administration building, a library, a basketball coliseum, a university center, and a new president's home were all constructed during his presidency. This photo shows new steam pipes to heat campus buildings.

President Derryberry was interested in developing the academic program at Tech. He achieved accreditation for the individual programs as well as re-accreditation for the school; he established the master's degree program in several disciplines and the Ph.D. program in engineering; and he worked with the Tennessee General Assembly to change the school's name to Tennessee Technological University

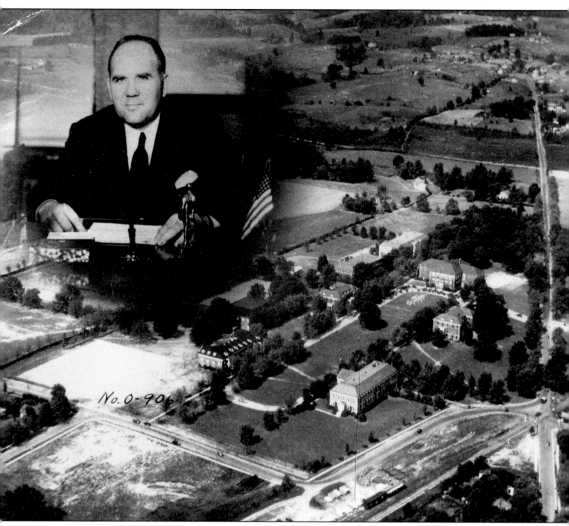

This photo is of TPI and Everett Derryberry upon his appointment in 1940.

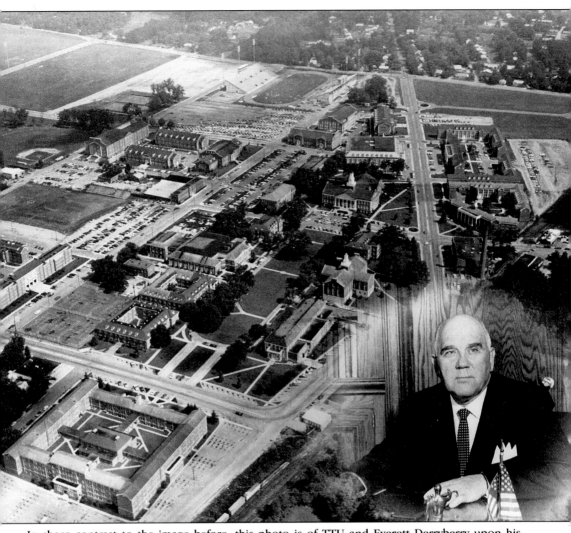

In sharp contrast to the image before, this photo is of TTU and Everett Derryberry upon his retirement in 1974.

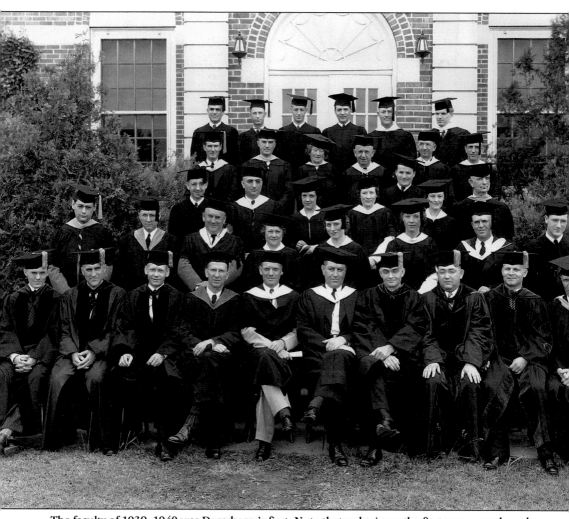

The faculty of 1939–1940 was Derryberry's first. Note that only six on the first row wear the robes indicating a doctoral degree, and seven faculty members were women. This photo was made in front of the Home Economics Building.

Elsie Jobe was TPI's first dean of women. She earned her B.A. and M.A. degrees at Peabody. In 1927 she came to Tech as a physical education instructor, and in 1928 she was appointed dean of women, serving until 1945. She was also the women's basketball coach. Jobe Hall was named for her in 1971.

Dr. Gordon Pennybaker came to TPI as chair of the Biology Department in 1946. He later became the first Dean of the College of Arts and Sciences. He retired in 1969 and died in 1983. Pennybaker Hall was named for him in 1971.

Beginning in 1930 Herman Pinkerton was the first debate coach at TPI. In 1951 Tech teams were invited to the National Competition debates at the United States Military Academy. Tech won the Tennessee Intercollegiate Forensic Tournament several times during the 1950s, and in 1955 Tech debaters won the All-Southern Debate Tournament. In 1962 Tech was again invited to West Point. Pinkerton retired in 1964.

Tom William Kittrell graduated from TPI in 1929 and earned his master's degree from Peabody in 1939. Tech's second bursar, he served as the business manager of the school from 1918 to 1967. Kittrell Hall, then the business school building, was named in his memory.

Dr. T.J. Farr came to TPI in 1929 as chair of the Department of Education. He earned his Ph.D. from the University of Colorado. Farr became the first director of the School of Education, serving until his death in 1962. In 1934 he helped found the Tennessee Folklore Society. The T.J. Farr Building is named for him.

Dr. Sidney L. McGee, who earned his doctorate at the University of Montpellier in France, became head of the Foreign Language Department in 1939. The department was created in 1926, although foreign languages had always been taught at TPI. McGee served until his retirement in 1968. For many years, he acted as the unofficial sports information director, and he was a sports correspondent for the *Nashville Banner* and Cookeville's *Herald-Citizen*. He died in 1976.

Louis Johnson joined the Department of Business in 1936, becoming chair during World War II. When the College of Business Administration was created in 1964, Johnson was appointed the first dean. He retired in 1978. Johnson had attended TPI as a student, receiving his B.S. degree from Bowling Green (Kentucky) College of Commerce. He earned his L.L.B. degree at Cumberland University in 1934 and his M.A. degree at Northwestern University in 1941. Johnson Hall was named in his honor in 1971.

James Seay Brown received his degree in engineering from TPI in 1941. In 1950 he earned his M.S. in mechanical engineering from the University of Illinois. Beginning as an instructor of engineering at TPI in 1941, he became dean of the College of Engineering in 1961. He retired in 1979. Brown Hall was named in his honor.

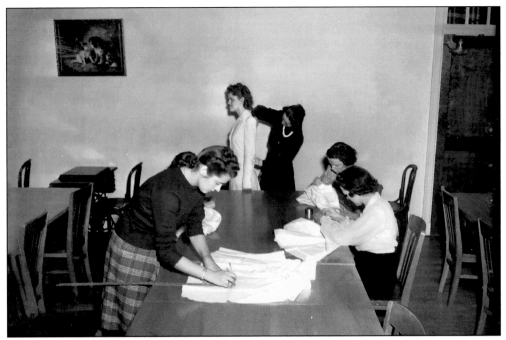

Pictured here is a home economics class of dressmaking in the 1940s. Home economics courses were taught at TPI from the school's beginning. Marie White became director of the Division of Home Economics in 1949.

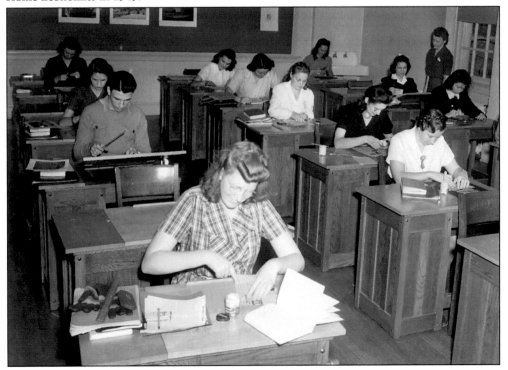

Elizabeth Cole sits on the front row of this business administration class. Business classes were taught in the Administration Building in the 1940s.

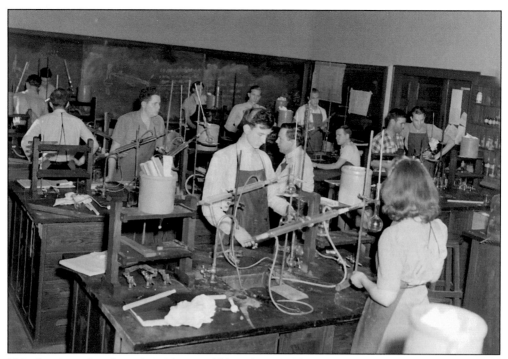

This chemistry class from the 1940s would have been held in the Science Building, later renamed the T.J. Farr Building.

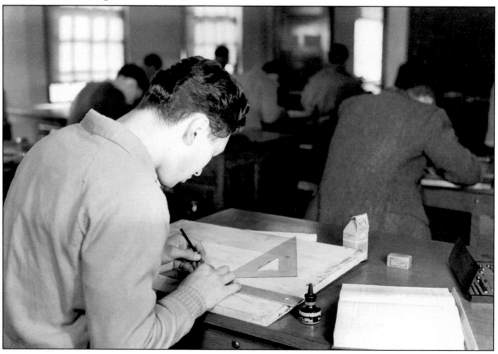

Engineering was a popular subject after World War II, and engineering students in 1942 were enrolled in a mechanical drawing class. The Engineering Building (now Henderson Hall) was the location of most engineering classes.

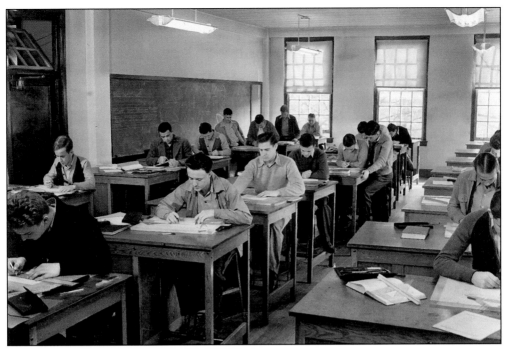

This engineering class on an upper floor in Henderson Hall demonstrates that most engineering majors in the 1940s were male.

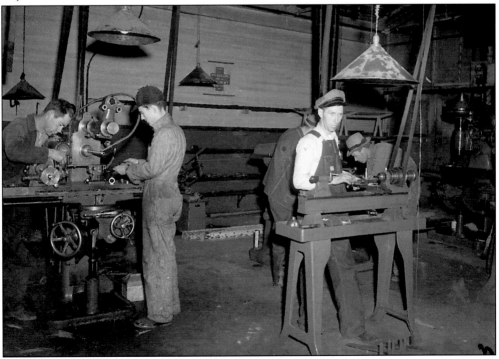

This is an industrial arts class from about 1950. The Department of Industrial Arts had its own building behind the Engineering Building. Today this building is the Lewis Building, in memory of W.H. Lewis, head of the department in 1947.

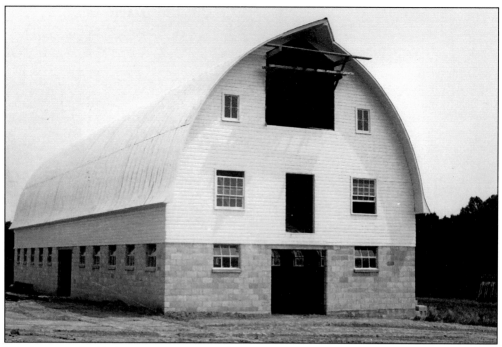

This barn on the Tech campus was part of the agriculture program. Agriculture courses were always part of the curriculum, and the School of Agriculture and Home Economics was organized in 1949. J.E.Conry, Willis Huddleston, and Clyde Hyder were popular administrators and instructors in the school.

The Home Economics Building and Henderson Hall are similar in appearance because they were designed by the same architect and built at the same time in 1931. In 1954 the building was enlarged to become the Tech Union, housing the cafeteria and the Home Economics Department. Later it was the Library Annex and then became a classroom building again.

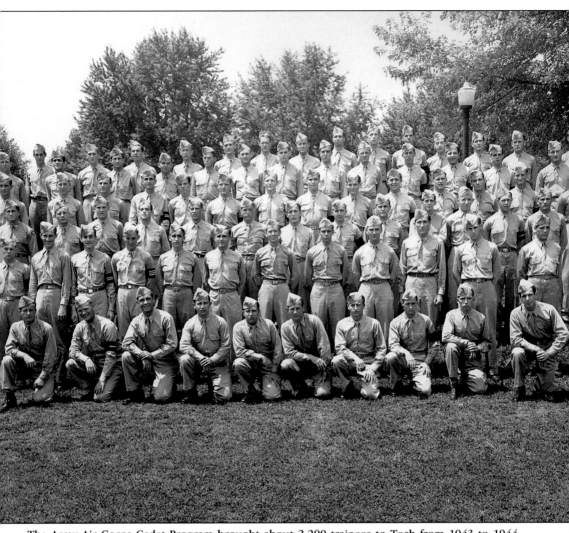

The Army Air Corps Cadet Program brought about 2,200 trainees to Tech from 1943 to 1944. Cadets participated in a 16-week pre-flight training program, and then went to flight schools at military bases. Tech's student enrollment went from 969 to 359 during the war, so these cadets were welcomed by both the administration and the co-eds.

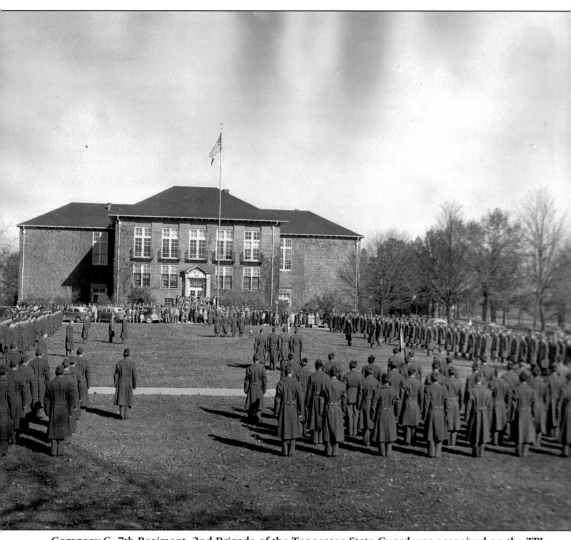

Company G, 7th Regiment, 2nd Brigade of the Tennessee State Guard was organized on the TPI campus in 1941. Maurice Haste of the Music Department was the commander. Calvin Frey of the Physical Education Department succeeded him. Officers included C.P. Snelgrove, Hooper Eblen, W.H. Lewis, and C.P. Philpot.

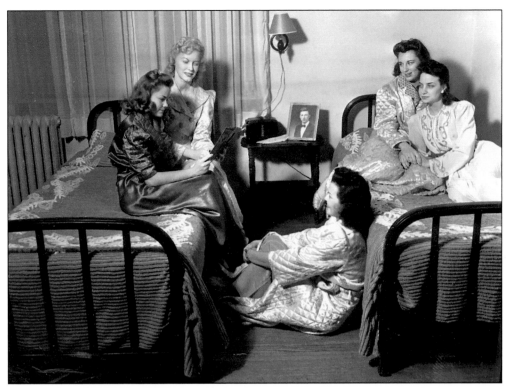

A group of co-eds relax and chat in South Hall dormitory in 1942. Two girls lived in each room and the cost for each student was $15 per quarter.

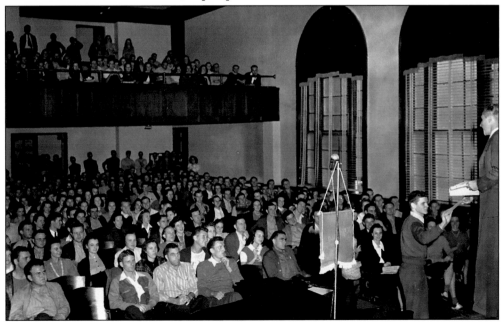

Tech students were required to attend chapel four times a week until 1939. Later, the Public Programs Assembly met for one hour each Wednesday in the auditorium of the Administration Building. Programs were religious, political, or educational.

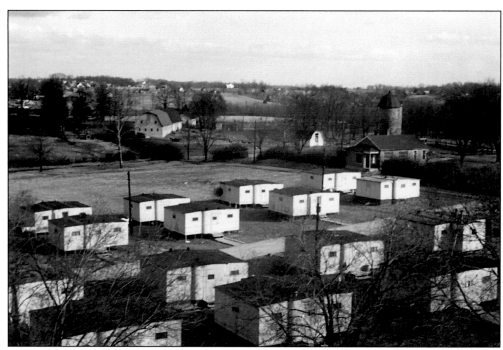

After World War II enrollment ballooned at all colleges. Many schools obtained buildings from the military to use temporarily as classrooms and housing. Pictured here are housing units for married veterans. The area was named "Cottage Grove" but nicknamed "Boxtown."

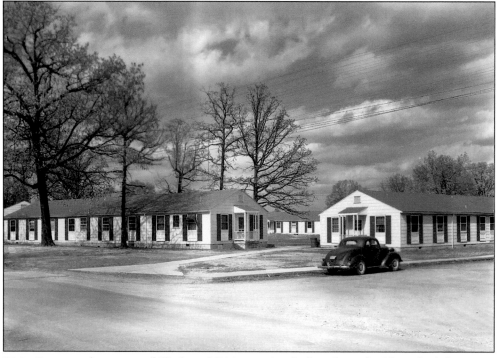

Dixie Courts at the corner of Ninth and Dixie consisted of six frame buildings built by TPI to house students.

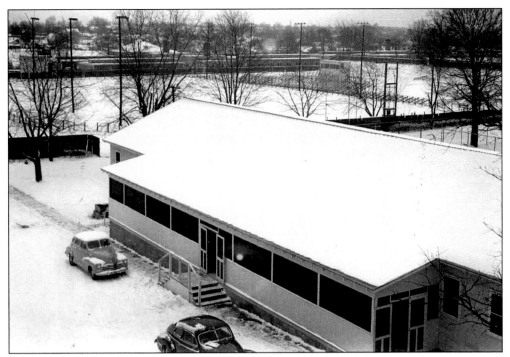

This temporary student union building, called West Annex and located behind Bartoo Hall, served until 1954 when the Home Economics Building was converted into the Tech Union. The annex contained a restaurant, post office, shop, and offices.

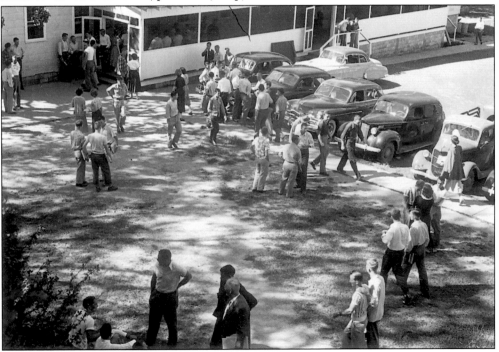

West Annex was a popular gathering place for students around 1950. Note that most of the vehicles are pre-World War II.

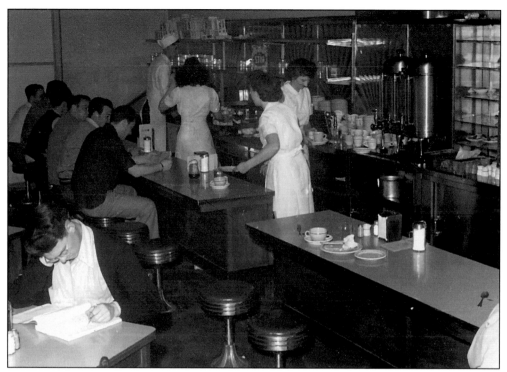

This scene depicts one of the local restaurants popular with students in the 1950s. Note the pie safe and the large coffee maker on the right.

Students snack on sandwiches and coffee while preparing for their classes. Note the jukebox selection box behind the girl's head. Five cents would play the tune of your choice. Bettye Rogers is seated center.

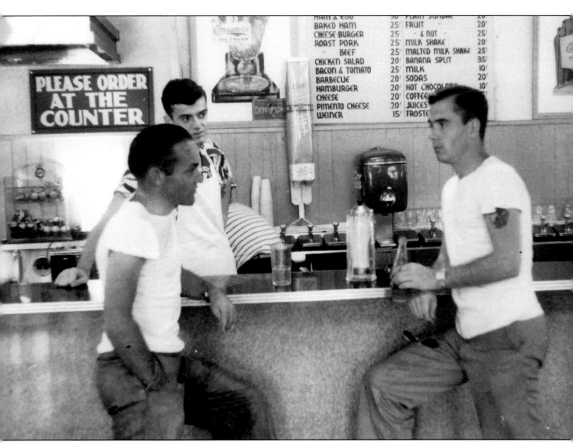

Here students enjoy the cheap prices of sandwiches and other meals in the early 1950s. T-shirts became popular among men after World War II.

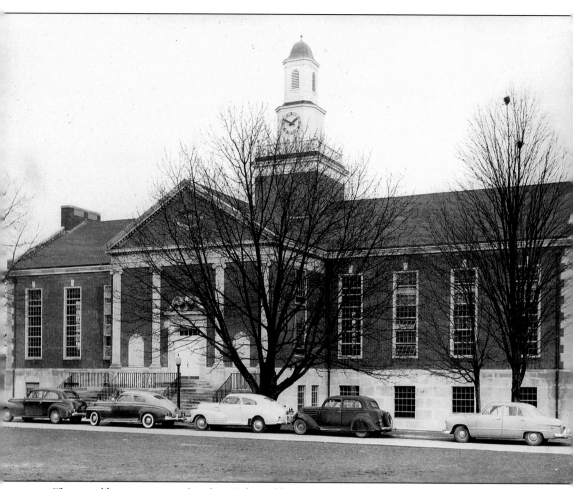

The new library was completed in 1949 and became the first building constructed after the war. The ground floor had a small auditorium that was used as a theater. The main floor had a large reading room with a two-story ceiling. The top floor was air-conditioned. Steel stacks had a capacity for 125,000 volumes. The clock, the clarion, and the eagle were later removed to the Administration Building.

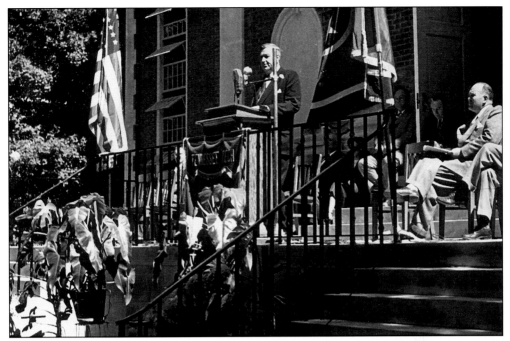

Governor Gordon Browning spoke at the new library's dedication on September 22, 1949. President Derryberry is seated on the right. The "stage" is the front entrance platform of the library. An audience of 3,000 people was seated on the lawn of the quadrangle.

The library used a card catalog and the well-known Dewey Decimal System to organize its books and other materials.

Christine Spivey Jones graduated from TPI in 1947 with a major in business. She served on *The Oracle* staff and *The Eagle* staff and was Tech's Sweetheart in 1947. She did her graduate work in library science at Peabody College and returned to Tech as a librarian in 1948. In 2001, she was the longest serving employee in the history of the school.

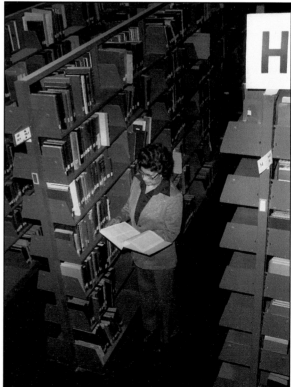

The steel stacks of the new Jere Whitson Library dwarf Mattie Sue Cooper, a librarian at Tech from 1945 to 1979. Miss Cooper graduated from TPI and received her library degree from Peabody College.

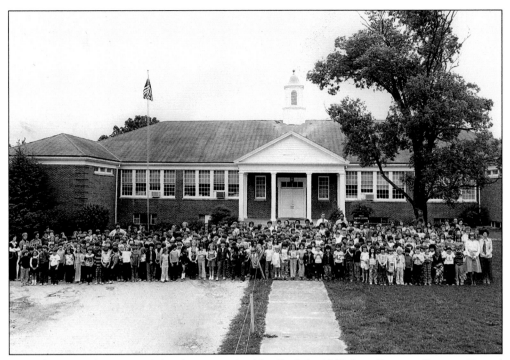

Seventh Street Elementary School was acquired by Tech in 1949 from Putnam County. Named Tech Training School, the Campus School was used for practice teaching by TPI education students. It was considered a superior school and many Cookeville children received their first education here. In 1976 the school closed but reopened in 1980 to house the new nursing program. The building closed again in 2000.

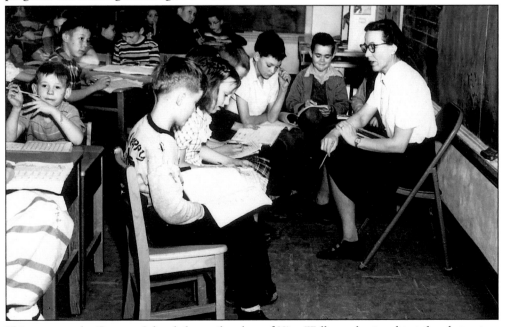

This scene at the Campus School shows the class of Nina Walker, who taught at the elementary school in the 1950s and 1960s.

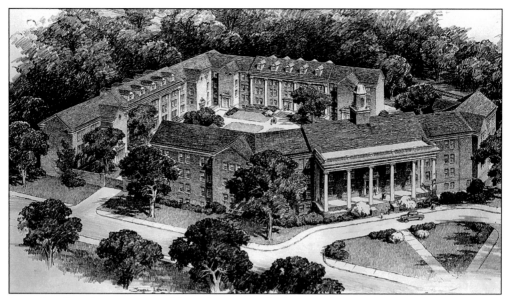

Dixie Quadrangle, consisting of four dormitories built around a courtyard, cost more than $1 million in 1957. They were the first permanent dormitories for women constructed after the war. These buildings housed several hundred students. The dorms had laundry rooms and television lounges and were considered very modern.

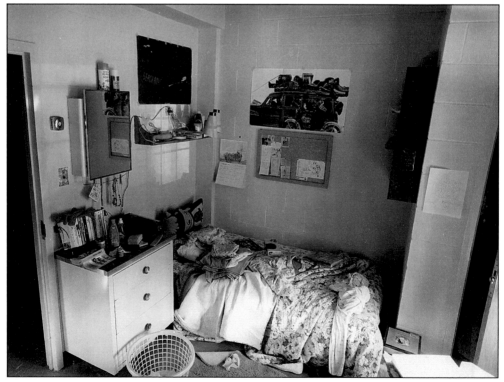

Built of concrete block, the dorms were quick and relatively cheap to construct. Rooms did not have private baths, but all such facilities were "down the hall." A women's dorm room housed two students.

66

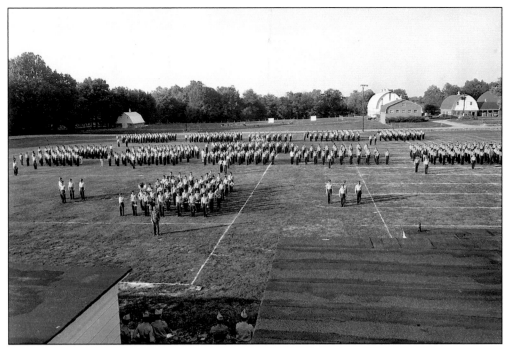

An ROTC unit was added to Tech's curriculum in 1950. By 1951, enrollment had increased to 740 students, giving Tech the largest Signal Corps ROTC unit in the nation. This photo of the 1956–1957 class shows the Tech agricultural barns in the background.

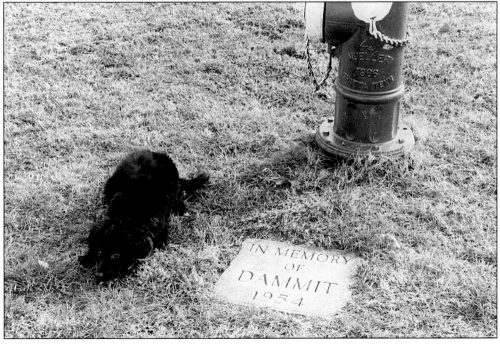

"Dammit," an unofficial mascot of the Tech students, was killed by an automobile in 1954. He was buried on the quad in front of the Administration Building. President Derryberry was credited with naming the dog after it jumped on his trouser leg with muddy paws.

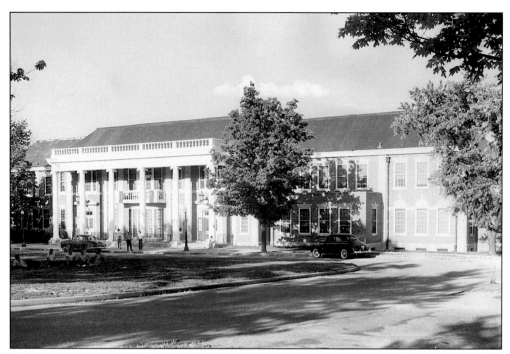

The Home Economics Building was expanded and converted into the student union building in 1952–1954. Replacing West Annex, the building had a cafeteria, bookstore, post office, and recreation room. A Greek-style portico was added to the front of the building to create an imposing entrance.

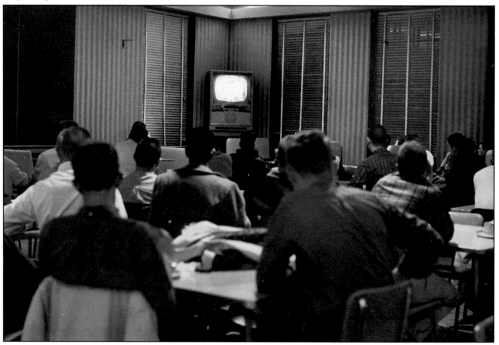

Student pictured here watch television in a lounge of the new Tech Union. Students did not have TV sets in their dorm rooms in the 1950s so they watched in the dorm lounges or at the union.

The cafeteria in the Tech Union was the first such modern facility at Tech. This cafeteria was so popular that faculty regularly ate there and townspeople often had Sunday lunch at the Union.

The Beacon restaurant at Eighth and Dixie, offering lunches, dinners, short orders, and fountain service, was a popular gathering place for Tech students in the 1950s and 1960s. Mr. and Mrs. Don Crouch owned the restaurant. In the 1940s, the establishment was called Boman's.

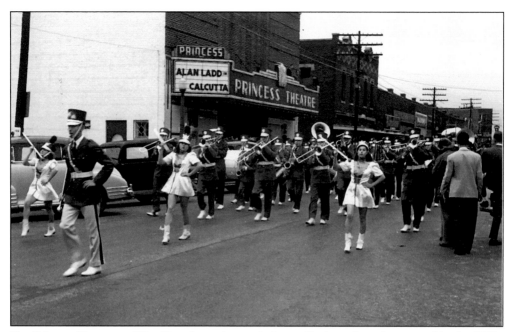

The Princess Theater on West Broad was the movie house Tech students frequented in the 1950s and 1960s. Originally segregated, the theater had a side door in the alley where African Americans entered. The Princess closed in 1978.

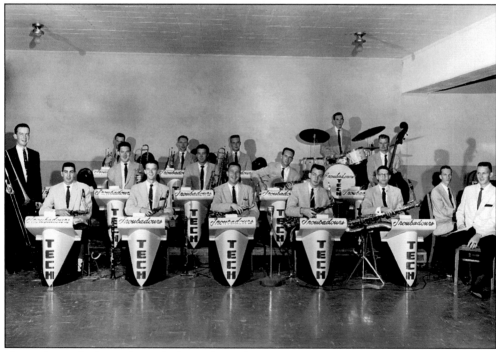

The Tech Troubadours, formerly the Tech Ramblers, was organized in 1950 with 13 instruments and 3 vocalists. They played for dances on campus and in other towns. Maurice Haste was the faculty member who supervised the group, although the director was always a student. W.J. Julian joined Haste on the music faculty in 1951.

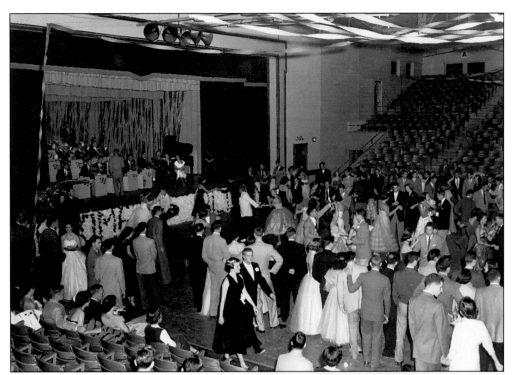

This photograph shows a freshman reception in Memorial Gym in the 1950s. The Tech Troubadours played for the dance. The bleacher seats accommodated fans at TPI basketball games.

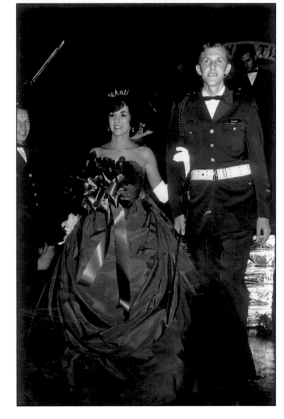

The Military Ball was an annual event sponsored by the ROTC. A formal affair, the ball was attend by the president and faculty, as well as cadets and their dates. This photo shows the queen, Judy Brown, and her escort at the 1963 ball.

Donald Caplenor, who earned his Ph.D. in biology-biochemistry at Vanderbilt University, came to Tech in 1966 as chair of the Science and Mathematics Division. In 1973 he was appointed chair of undergraduate studies and in 1976 he became associate vice president for research. In 1979 Caplenor died in an accident at Fall Creek Falls State Park. An overlook in the park is named in his memory.

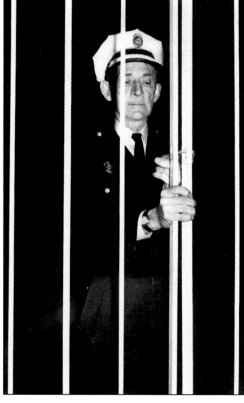

Arch Carrington, nicknamed "Uncle Arch," was the night watchman at TPI between 1929 and 1933. His son Bethel, seen here, succeeded him in 1933 and served as night watchman until 1970.The students nicknamed Bethel "Sherlock." Sherlock Park on the Tech campus is named in his memory.

In the 1960s Tennessee changed the names of state colleges to universities. In 1965 the state legislature changed Tennessee Polytechnic Institute's name to Tennessee Technological University. President Derryberry chose the name so that "Tech" would still be the nickname of the school.

Gov. Frank Clement, a close friend of President Derryberry, signed the bill making TPI a university. Witnesses were Derryberry, Comm. of Education J. Howard Warf, Lt. Gov. Jared Maddux of Cookeville, and Rep. Vernon Neal of Cookeville.

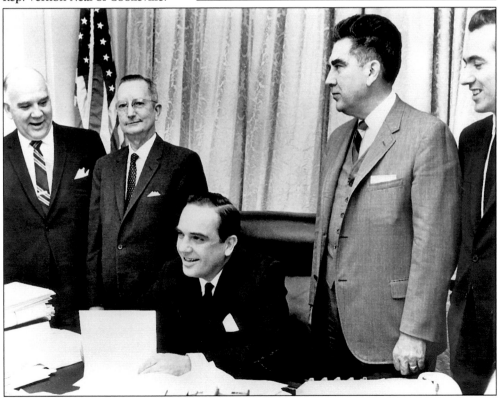

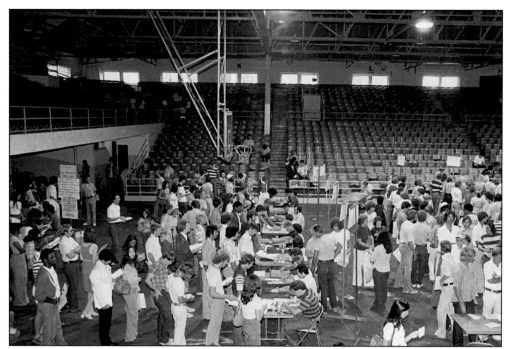

Before computers became available, Tech students registered for all their courses in Memorial Gym. Each student received a separate card for each class. This photo was taken in about 1970 when enrollment was 5,784.

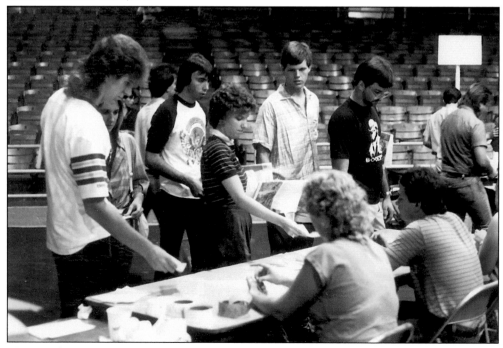

These students complete registration in Memorial Gym. In the early 1970s registration was moved to the classroom buildings. IBM punch cards were then given to the students for enrollment in classes.

In 1958 Tech organized its graduate school. Dr. Barksdale was director of the school, and a dozen professors with doctoral degrees were the core faculty. Education, chemistry, biology, mathematics, and history offered the first master's degrees. This photo shows the first class of graduate degrees in 1960.

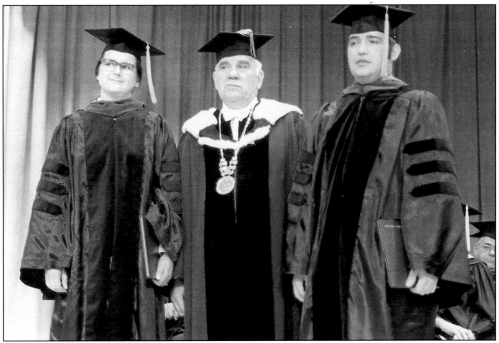

In 1971 Tech initiated its Ph.D. program in engineering. The first two graduates, in 1974, were Marie Ventrice and Charles Baxter. Ventrice immediately joined the Tech faculty. By 1985, TTU had awarded 27 doctoral degrees.

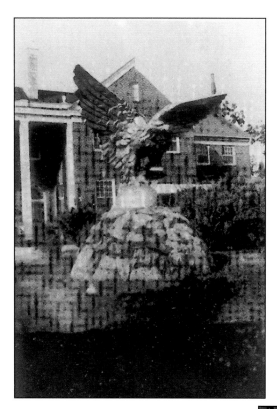

Tech's official mascot, the golden eagle, was adopted by the school in 1925. In 1952 three Tech students stole this metal bird from Monteagle Hotel after the building burned. It was presented to President Derryberry in student assembly. After some negotiations, Tech paid $500 for the bird in 1961.

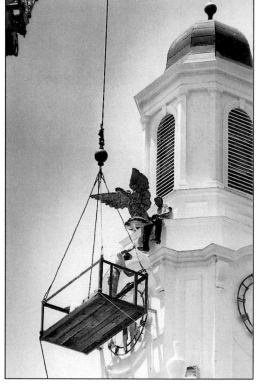

The golden eagle was first mounted on Whitson Library in 1958, and then it was mounted on the Administration Building in 1961. The bird weighs 70 pounds and has a four-and-a-half foot wingspan. Periodically it is lowered to the ground for repainting.

Flavious Smith came to Tech as chair of the Health and Physical Education Department. He attended TPI as a student from 1948 to 1952 and played football during those years. He played for the Los Angeles Rams in 1952 and the Pittsburgh Steelers in 1953.Completing his doctorate at Peabody College, Smith returned to Tech to teach in 1962. He retired in 1995.

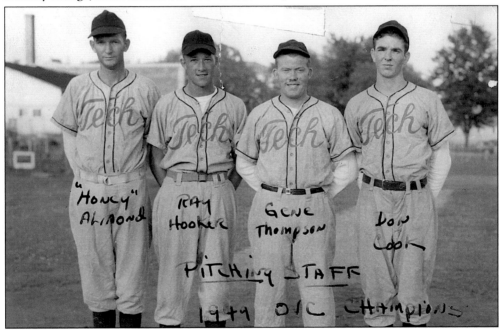

Tech's baseball team won the Ohio Valley Conference championship in 1949. Tech won 10 games that year, including a victory over Vanderbilt. The pitching team, shown here, were "Honey" Almond (1-0), Ray "Lefty" Hooker (1-0), Gene Thompson (3-2), and Don Cook (6-1). Cook later earned a Ph.D. in accounting and joined the Tech faculty in 1956.

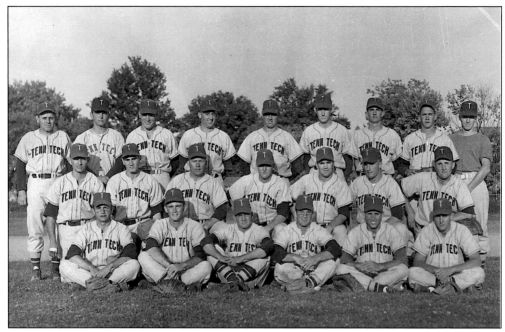

In 1956 Tech won the Ohio Valley Conference championship again, winning 13 games. This was the team's second straight title. Coach Malcolm "Mutt" Quillen, standing on the back row, left, attended Tech in the 1930s, earning 10 varsity letters. In 1954 he returned to Tech as head baseball coach and assistant football coach. He was dean of men from 1958 to 1975. Quillen Baseball Field is named in his honor.

The health and physical education building, Memorial Gym, was built in 1949. In 1951 a new wing and a new front were added, giving the building its present appearance. The renovations included an indoor swimming pool, classrooms, offices, and a 5,000-seat gymnasium/auditorium with a stage.

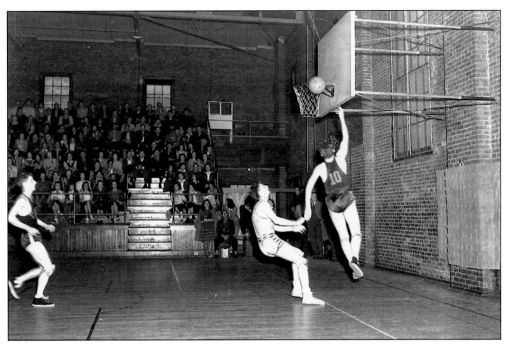

This 1942 basketball game was played in TPI's first gym, which was constructed in 1929. Number 10 was team captain Glen Davis. Under Coach Hooper Eblen, the team won nine games and lost six that year. Eblen joined the Tech faculty in 1941 as a math instructor and basketball coach. In 1947 he became head football coach and in the 1960s, he was the athletic director. Hooper Eblen Center is named for him.

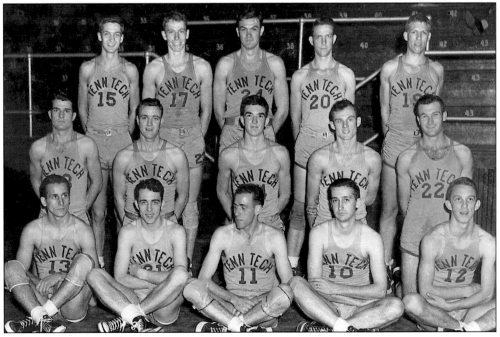

In 1949 Tech joined the new Ohio Valley Conference. This team played in the OVC tournament that year. The team won nine games and lost nine in 1949.

79

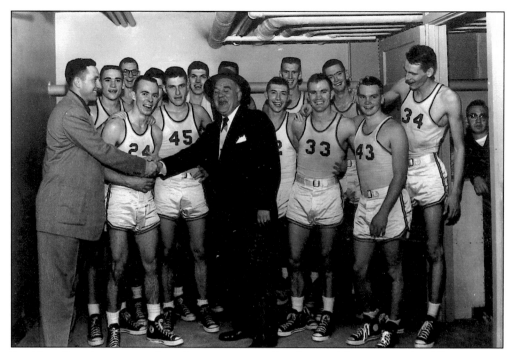

President Derryberry joyously welcomes new coach Johnny Oldham in 1956. Oldham was an All-American at Western Kentucky State College. With fourteen wins and seven losses that year, Tech claimed a share of the OVC title. In 1958 Oldham's team won its first undisputed OVC championship.

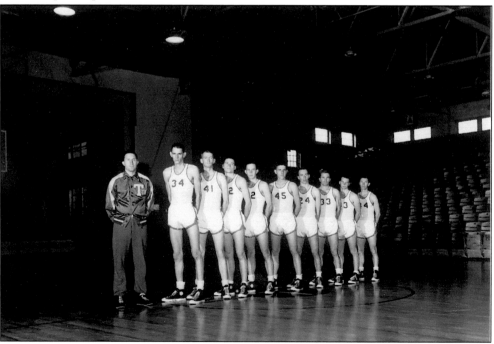

In 1962 this Tech team compiled a 16-6 record for Coach Oldham. The next year they shared the OVC title and attended the NCAA playoffs. Third-ranked Loyola defeated them there.

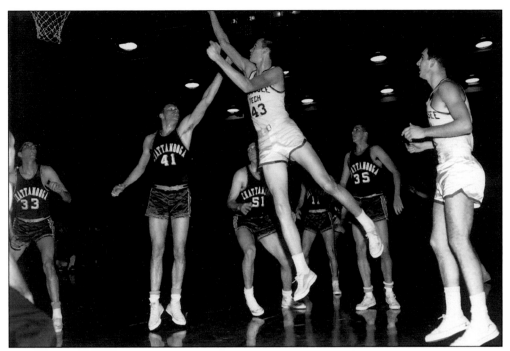

Jim Hagan, (number 43), who graduated in 1960, compiled a number of records. He scored 48 points in a game and 720 in one season, with a field goal percentage of 46.4. He also broke records for free throws and total rebounds. Hagan was selected as an All-American player in 1959.

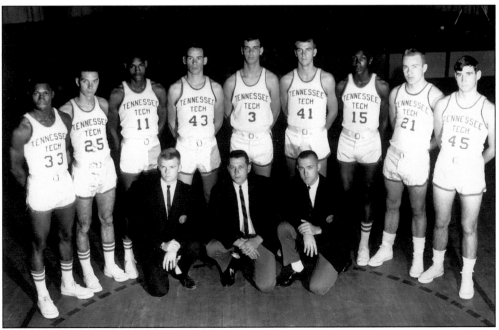

Tech played its first African-American athletes Joe Hilson, Marvin Beidleman, and Henry Jordan in 1965. This freshman team was coached by Cleve Nichols and John Hayes (kneeling). The team defeated the University of Tennessee and won 17 out of 19 games.

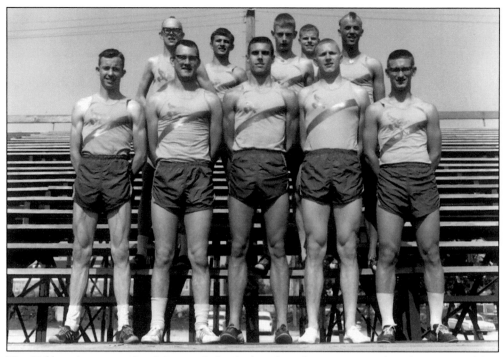

The 1964 track team, with a 3-3 record, finished sixth in the OVC, second in the TIAC, and first in the college division of the News-Piedmont Relays. Dr. Nolan Fowler of the History Department coached the team in the early 1960s.

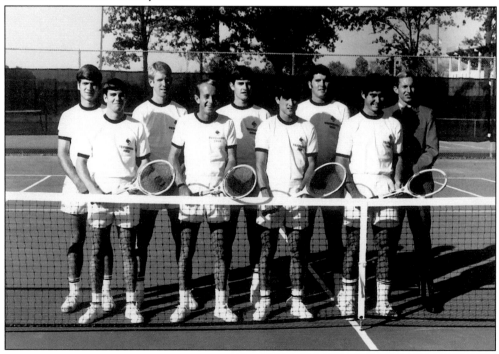

With a 20-2 record in 1969–1970, Coach Larry Ware's tennis team won its first OVC title. Ware was named OVC Coach of the Year.

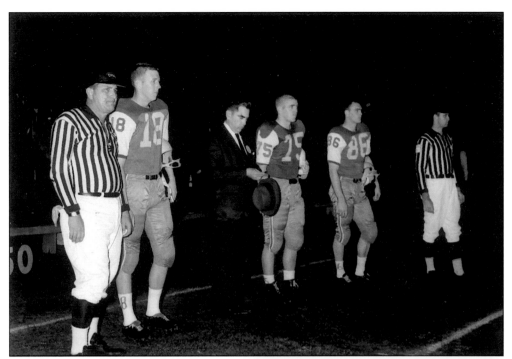

In 1952, under Coach Overall, Tech's football team compiled a 9-1 record, losing only to Middle Tennessee State College in the last game. In January, Tech accepted an invitation to the Tangerine Bowl in Orlando, Florida. Jared Maddux,the Tennessee State Legislator from Cookeville, stands on the sidelines with some of the players and officials.

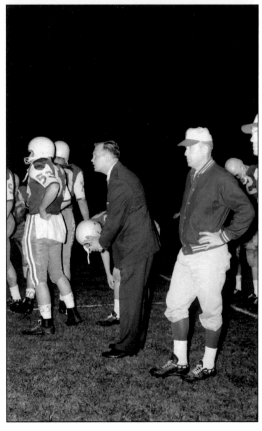

Tech was defeated 33-0 by East Texas State in the Tangerine Bowl. This was the 19th straight victory for East Texas. Coach Overall retired after this game, and Wilburn Tucker, pictured at the far right in this photo, became head coach in 1954. He served 14 years as head coach and won 5 OVC championships. Tucker was a graduate of Tech in 1943, playing both football and baseball.

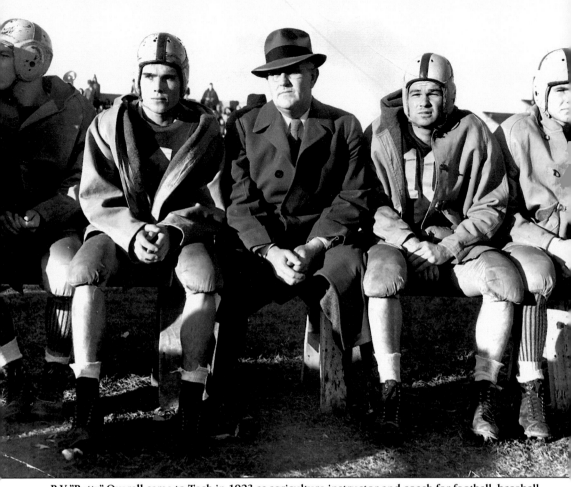

P.V "Putty" Overall came to Tech in 1923 as agriculture instructor and coach for football, baseball, and basketball. He was head football coach from 1923 to 1947. He came out of retirement to coach the 1951–1952 season. This 1940 team complied a 2-6 record. Team captain John Billings is on Overall's right.

Four

TENNESSEE TECHNOLOGICAL UNIVERSITY 1974–2000

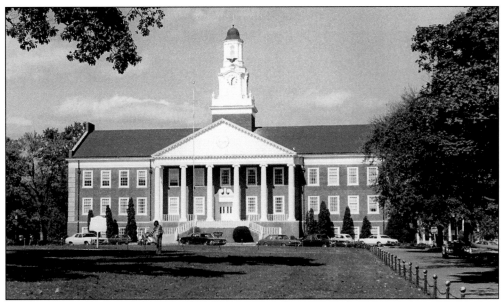

The Administration Building assumed its final shape with the remodeling of 1960. The old building was completely encompassed in the new one. Floor space was doubled to 60,000 square feet, the structure was air-conditioned, and a Greek-style portico was added to the main entrance. The new name for the building was Everett and Joan Derryberry Hall.

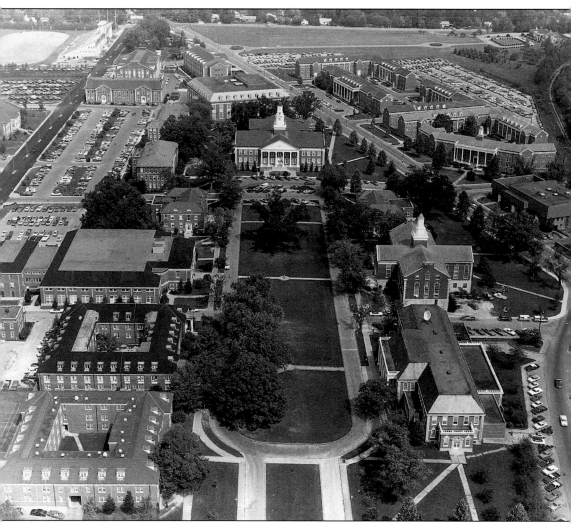

This aerial view of the campus about 1970 shows the post-World War II expansion. New women's dormitories, in the upper right hand corner, and new classroom buildings, in the upper left hand corner, were built to accommodate the increased enrollment after the war. The football stadium in the left corner was completed in 1964.

When President Derryberry retired in 1974, Dr. Arliss Roaden was chosen to succeed him. Dr. Roaden, a Kentucky native, earned his college degrees in Tennessee. He came to Tech from Ohio State University, where he had been dean of the College of Education, dean of the Graduate School, and vice provost of the university. He served as Tech's president from 1974 to 1985, when he became executive director of Tennessee Higher Education Commission.

President Roaden resigned rather suddenly, and Dr. Wallace Prescott became interim president. Prescott graduated from Tech's engineering program in 1946 and joined Tech's faculty that year. In 1962 he earned his Ph.D. from the University of Illinois and became dean of faculty at Tech. Between the years of 1970 and 1976, he was vice president, and after 1976, he was provost and vice president. Prescott retired in 1983 but returned for three years service as interim president in 1985. Prescott was later interim president at Middle Tennessee State University.

Dr. Angelo Volpe became Tech's president in 1987. A native of New York, Volpe was Tech's first non-southern executive. He earned a Ph.D. in chemistry at the University of Maryland and he was the vice chancellor for Academic Affairs at East Carolina University when Tech called. Volpe served as president until his retirement in 2000.

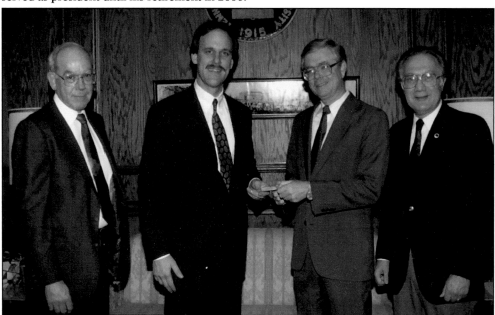

Dr. Robert Bell, third from left, succeeded Dr. Volpe as president. Bell earned his doctorate at the University of Florida in 1972. He came to Tech in 1976 as chair of the Department of Business Management in the College of Business. He became dean of the college in 1990. Pictured with President Bell are Vice Pres. Marvin Barker, left, and former president Angelo Volpe, right.

Walton House on the northeast side of campus has been the home of Tech's presidents since 1964. Tech's maintenance crews, supervised by Frank Moss, built the home. Two floors plus a basement provides living space for the family and public space for receptions and dinners. The building was extensively remodeled in 2000.

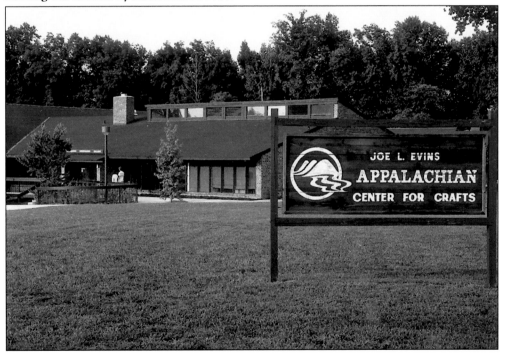

Constructed in 1979 with an Appalachian Regional Commission grant of $2.5 million, the Joe L. Evins Appalachian Center for Crafts is a state of the art facility located on Center Hill Lake. TTU offers a B.A. degree in wood, glass, fiber, clay, or metalwork.

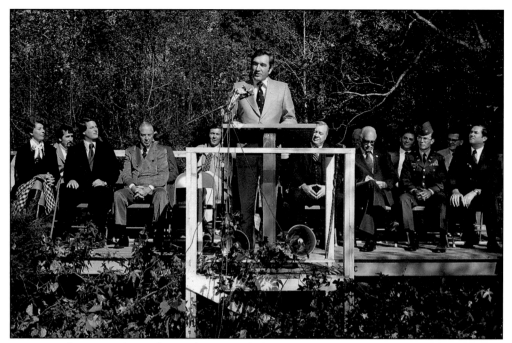

Gov. Ray Blanton spoke at the Craft Center dedication. Rep. Albert Gore Jr. is seated second from left on the front row. Former representative Joe L. Evins, who had secured the grant and for whom the Craft Center is named, is seated next to Gore. President Roaden is on the far right.

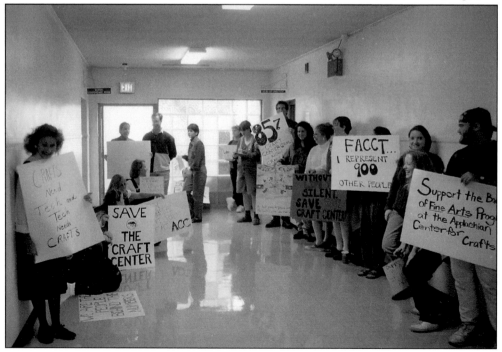

The Craft Center budget is an annual special appropriation, and in 1999–2000, there was the possibility of no appropriation. Students, as well as many in the community, protested and money was provided.

Clyde Hyder, who earned a degree in agriculture at TPI in 1940 and a masters degree at the University of Tennessee in 1941, returned to Tech as a faculty member in 1946. He later became chair of the Department of Animal Science, retiring in 1980.

Tommy Burks, a graduate of the agriculture program at Tech in 1963, served four terms in the Tennessee House of Representatives and five terms in the Senate. He was an effective supporter of Tech, particularly Tech's agriculture program. He was murdered by a political rival in1998.

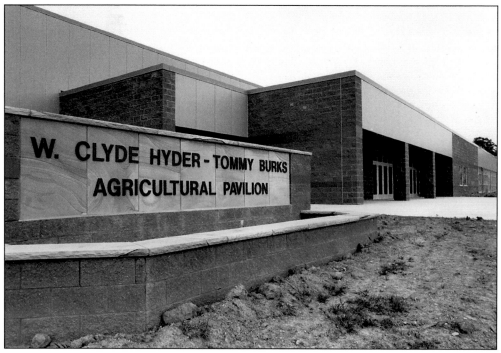

The Hyder-Burks Pavilion, built on the Tech Farm in 1992 and expanded in 1995, provides an arena and show pens for livestock shows. Tommy Burks's funeral was held here on October 21, 1998. He had been instrumental in securing funding for the building.

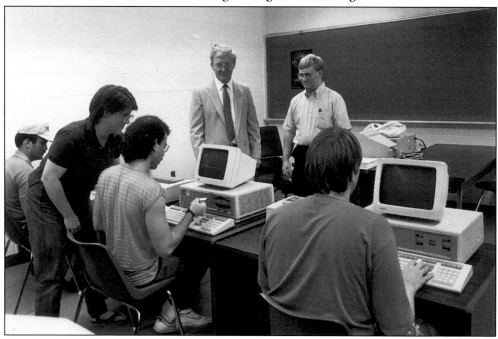

Computers came to Tech in the mid-1980s. Each faculty member was given one, and computer labs were set up for students. Pictured here are Dr. Joe Middlebrooks, vice president and provost (with tie), and Joel Seber, the microcomputer specialist.

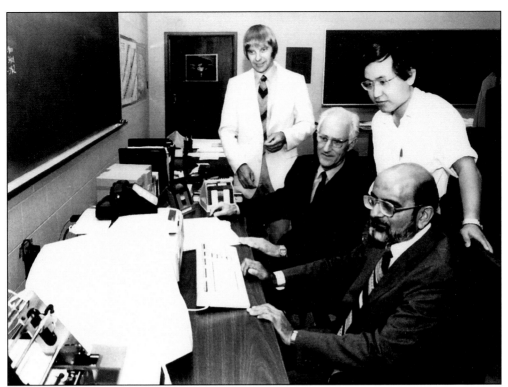

In 1983 Tech established three University Chairs to be filled by distinguished faculty members devoted to research. Dr. Krishna Kumar, on the right in the photo above, was a renowned professor of physics who held one of the chairs. Dr. Middlebrooks and Dr. Richard Lukas of the History Department, held the others.

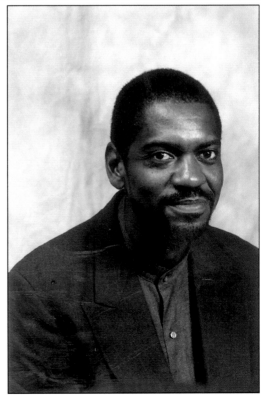

Dr. Carl Owens joined the faculty in 1981 while completing his doctorate at Tennessee State University. He developed a program of educational media studies in the College of Education, using the Jeffers Endowment of $1,000,000 to finance a state of the art computer lab. He directs Tech's 21st Century Classroom Project and is an Apple Distinguished Educator.

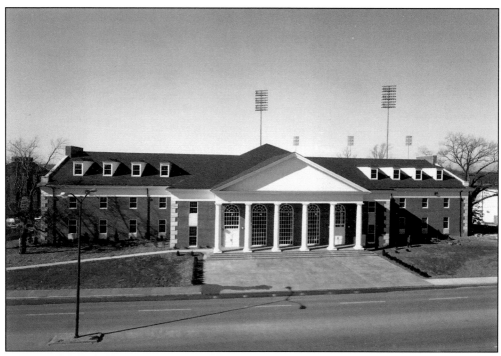

The Charles Bryan Fine Arts Building, completed in 1981, was named in memory of the Tech composer of the 1930s. The building houses the Music and Art Department of the university.

Joan Derryberry, wife of the president, came to Tech in 1940. She taught piano and music history and was an accomplished artist. Her art is a part of many homes in the state, and she had displays in the Tennessee State Museum. Mrs. Derryberry died in 1998.

Sally Crain-Jager joined the Tech faculty in 1968, earning her Master of Fine Arts degree at Texas Christian University. She taught art classes at the university and developed a video program called "Young at Art." She has taught at the Governors School for the Arts.

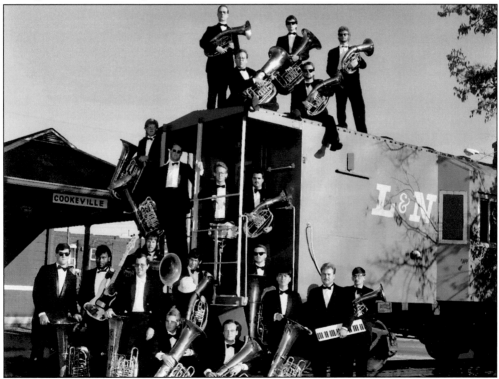

The Tennessee Tech Tuba Ensemble, created and directed by Dr. Winston Morris, third from the left, was the first university instrumental group to perform at Carnegie Hall, New York City. Three return engagements—1982, 1986, and 1990—proved the group's continuing popularity.

Robert Jager joined the faculty in 1971 as resident composer. By 1973, he had published 27 compositions. Many of his works have been commissioned and his music has been played all over the world. Jager retired in 2000.

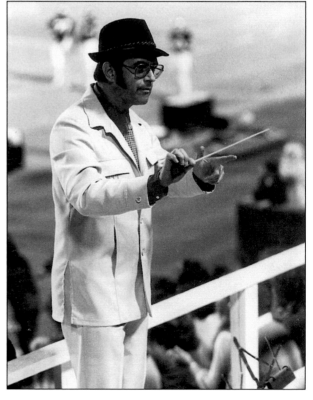

Dr. Wayne Pegram joined the Tech faculty in 1968 as director of bands. He graduated from Tech in 1959 and earned his Ph.D. at the University of Wisconsin. In the 1970s and 1980s, he published more than 60 compositions for bands. After 1985, he organized and directed band and choir concert tours of Europe.

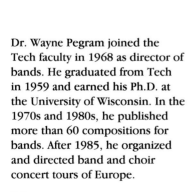

96

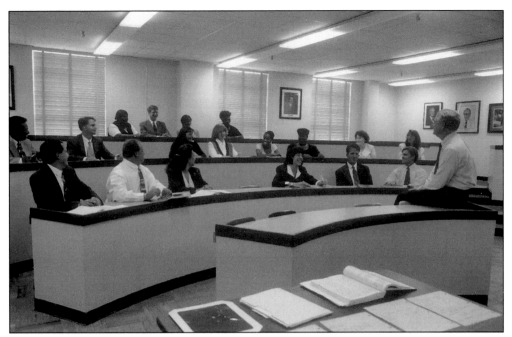

Tech's MBA program began in 1976, using the case method of instruction. With most of its classes held in the evenings, the program awarded its first degrees in 1978. Ten years later Tech's program was one of only three accredited programs in Middle Tennessee. Dr. Bell is pictured on the right.

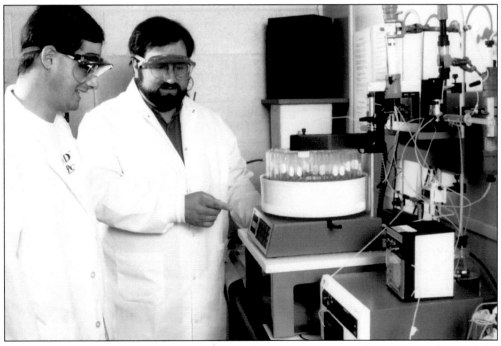

Dr. Jeff Boles earned his Ph.D. in chemistry at the University of South Carolina and joined the Tech faculty in 1994. Pictured on the right, Dr. Boles was interim director of the Ph.D. program in Environmental Science at Tech.

97

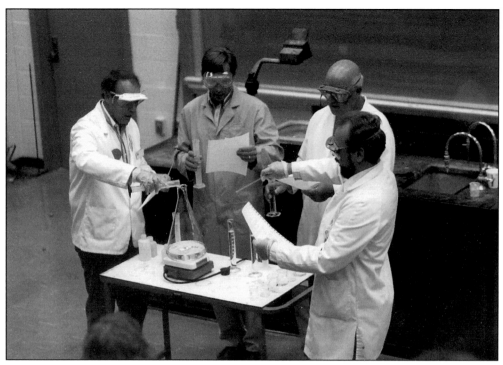

Tech chemistry professors rehearse an experiment in Foster Hall. From left to right are Dale Ensor, Frank Kutzler, Tom Furtsch, and Scott Northrup.

David Farrar, Department of Chemistry, teaches a large class in Foster Hall.

Dr. Gordon Hunter, who joined the Tech faculty in 1967, was famous for role-playing in the classroom. A professor of biology, Hunter impersonated famous scientists for his students.

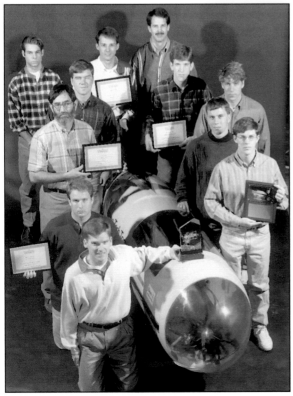

One of the national contests that Tech entered was the 1989 human-powered mini-submarine competition in West Palm Beach, Florida. In 1993 the Tech Torpedo II, pictured here, was the overall winner of the contest at Fort Lauderdale. Dr. Joe Scardina, on the left with beard, was the faculty advisor.

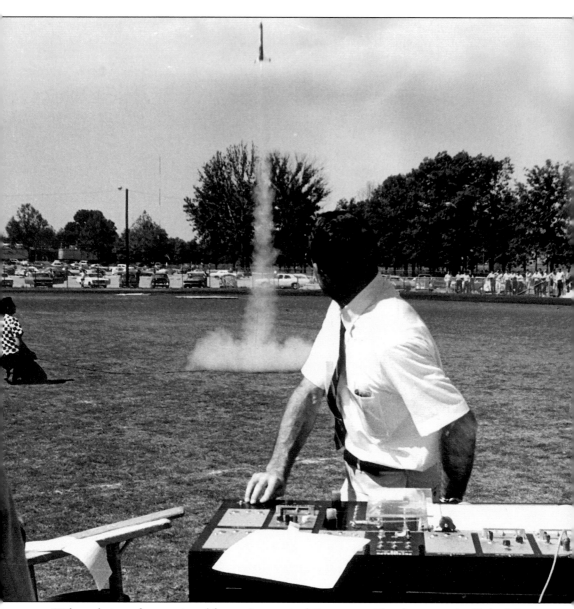

With rockets and space travel becoming part of the competition between the United States and the U.S.S.R after World War II, Tech joined the fray with rocket experiments. These efforts climaxed in 1970 with the Cosmouse experiment. A mouse installed in a rocket was shot into the air 3,000 feet to measure his heart and respiratory rate. Both increased.

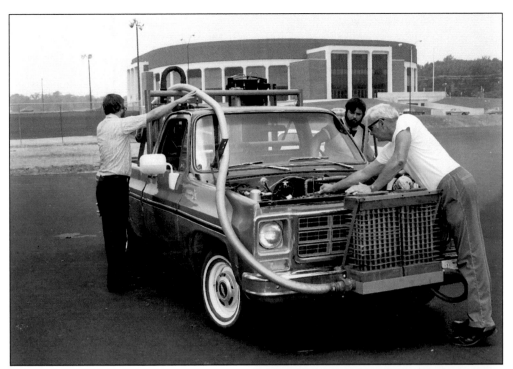

A vehicle powered by burning wood was another experiment conducted by Tech students. Called wood gasification, the burning wood produced gases, which powered the engine. Professor Vernon Allen is pictured on the right.

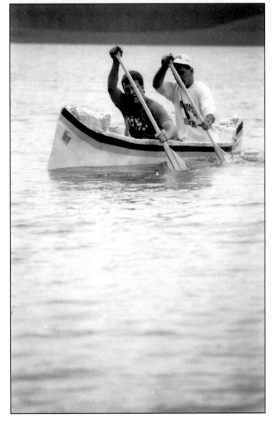

This concrete canoe was built by Tech civil engineering students for a competition. Named the "Rigid Member," the canoe is powered by Van Medlock and Martin Amundson at Cane Creek Park.

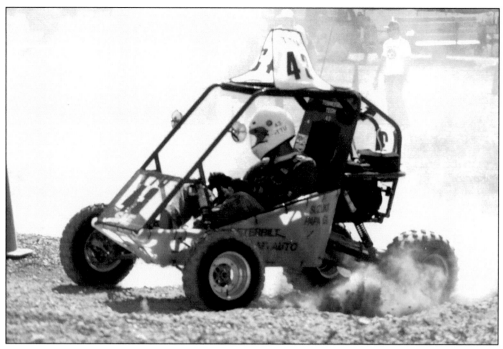

Since joining the Mini Baja race in 1977, Tech has won first overall honors seven times, including 2001. Built by engineering students, these all-terrain vehicles compete with similar vehicles from other engineering schools.

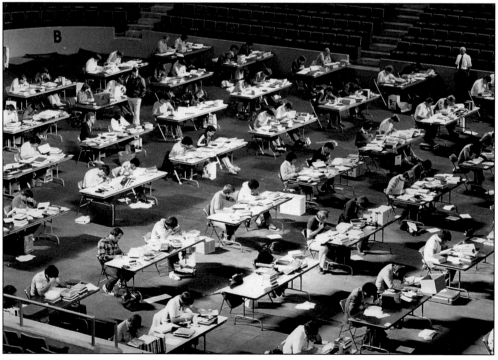

These Tech engineering students are taking an EIT exam in Hooper-Eblen. Professor Frank Alexander is the monitor standing in the upper right-hand corner.

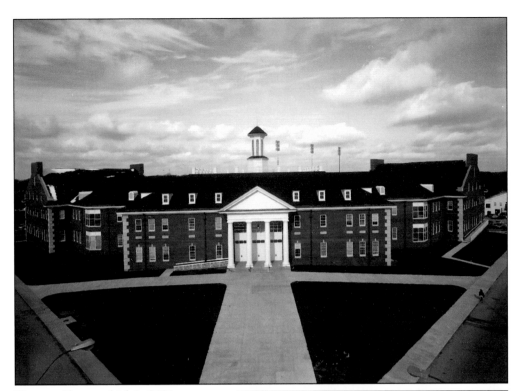

The new library, which in 2001 was named the Angelo and Jeanette Volpe Library, had been anticipated for a long time. Both Derryberry and Roaden had hoped to build it, but construction did not begin until 1987. It was completed in 1989 during Volpe's presidency.

This unidentified student is literally covered up by his books. The semester is about to end, and that paper assigned at the beginning of the term is due. Tech library has open stacks, whereby students can browse for books.

The tree-shaded, 122,000-square-foot library building consists of a central block and two wings. Housing 328,758 volumes, the library also has an archive section and a special collection specializing in local history.

Clement Hall, built in 1963 and named for Gov. Frank Clement, houses the administration offices for the College of Engineering, the mainframe for the university computer system, and some classrooms for engineering courses.

Capitol Quad, with dormitories named for Tennessee politicians and Congressman Joe L. Evins, houses male students. They were built in the 1960s by the Sorrell Brothers of Sparta, Tennessee, who constructed most of Tech's postwar buildings.

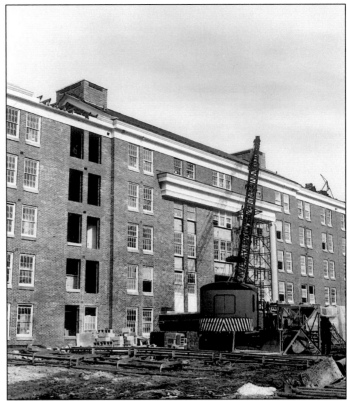

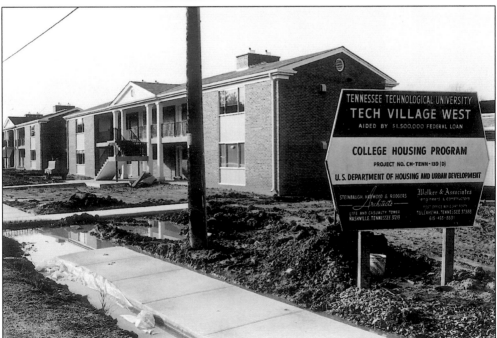

Tech Village, designed for married students, was constructed in 1967 and 1973 using bond money and federal loan funds. The apartments were built on either side of North Willow Avenue.

The Arliss Roaden University Center, which cost $3,300,000, was completed in 1971. It was the most expensive building project at Tech up to that time. Facing Dixie Avenue, the center houses the student cafeteria, banquet rooms, the bookstore, a grill, a post office, student meeting rooms, and lounges.

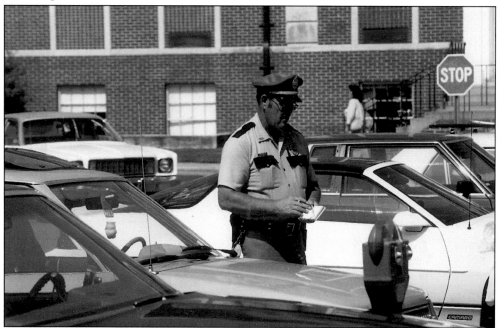

Parking is a problem on any campus for students, faculty, and visitors. Tech has a less severe parking problem than some other schools. Alex Robinson, a long-serving officer on the campus police force, writes a ticket for a student vehicle.

106

Betty Fine, left, secretary in the Chemistry Department, and Lois Clinton, History Department secretary, are both long-serving members of the staff. Both have been selected as staff of the year. These women are part of the support staff who administers the paper work of the university. They are an irreplaceable part of the university community.

In 1967 Tech allowed national social fraternities and sororities to organize on campus. Sororities like Alpha Delta Pi rented chapter rooms in dormitories. Pledge Nancy Anderson is on the left, and Linda Turnbill is second from the right.

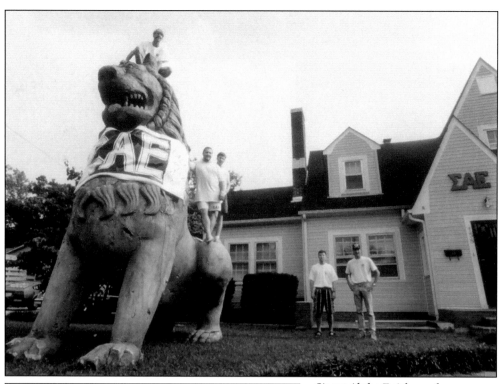

Sigma Alpha Epislon, whose emblem is the lion, placed this huge model at their fraternity house on Seventh Street. It had been a prop for the locally filmed movie, *The Jungle Book*.

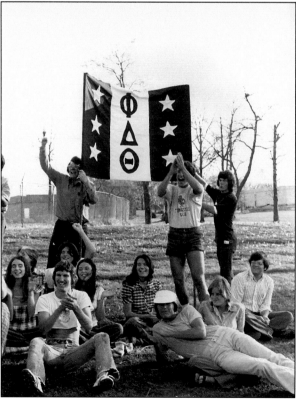

Phi Delta Theta cheers for its team in the fraternity athletics. Fraternities compete in most sports, and an All-Sports Trophy is awarded to the chapter who accumulates the most points in sports activities.

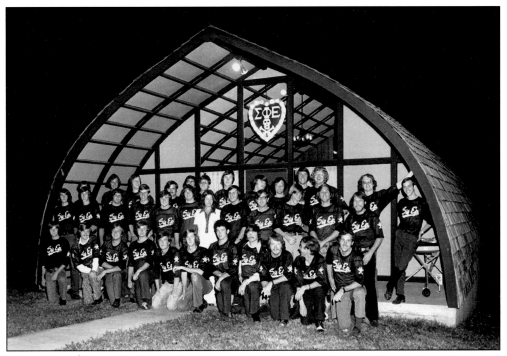

Sigma Phi Epislon regularly served meals to the brothers at this fraternity house. They also served dinners to each of the sororities once a year.

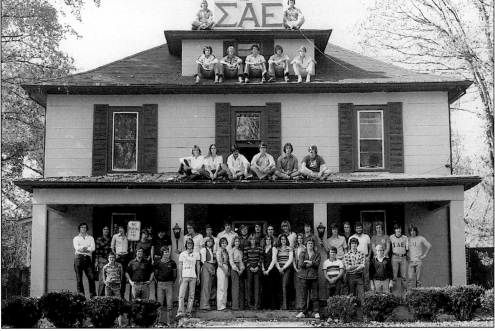

Fraternities and sororities are a very important part of university athletic events and homecoming celebrations. This SAE fraternity house was located on North Willow Avenue. The old residence housed about half of the membership. This Tennessee Delta Chapter was part of the largest national fraternity.

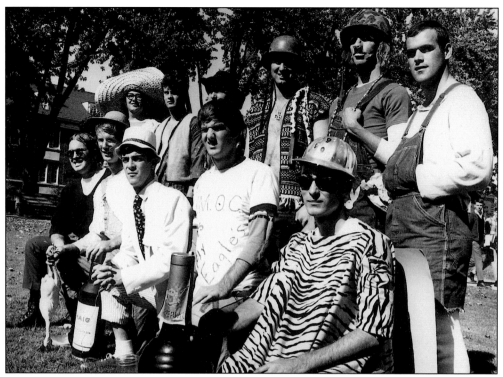

In the 1930s, Tech students elected a "bachelor of ugliness" each year. In the 1960s, the fraternities renewed this tradition for a short time. These are the candidates for the "ugliest man on campus" in 1969.

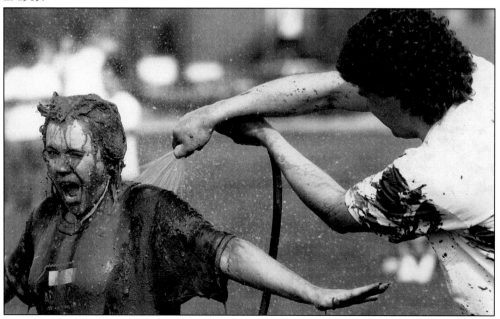

Oozeball was one of the games that Tech students liked to play. In this photo, Geeta Pratt is cleaned up by Jeff Roberts. Sometime after this photograph was taken, Pratt became director of alumni affairs.

Built in 1935, the Princess Theater on Broad Street showed second-run movies for students and townspeople. Students walked from the campus to this area, which had restaurants as well as the theater.

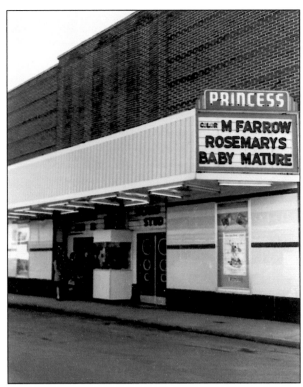

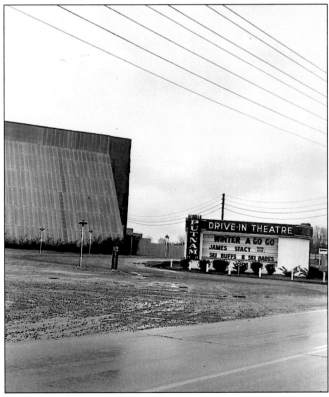

Putnam Drive-in Theater, on U.S. 70 west of town, became a favorite of students with cars. The movies were usually sub-standard, but many attendees did not watch them anyway.

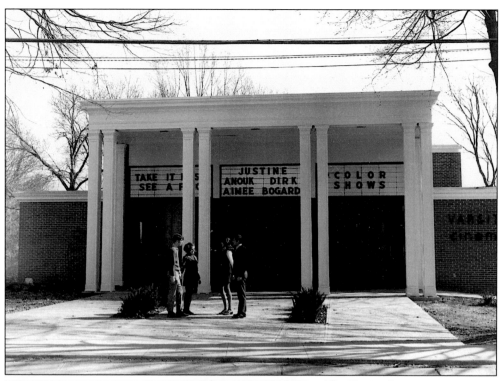

The Varsity Cinema was constructed by Leon DeLozier on Dixie Avenue close to the campus. This was the favorite theater for students in the 1970s, 1980s, and 1990s. It was split into two theaters in the 1980s, but was closed in 2000.

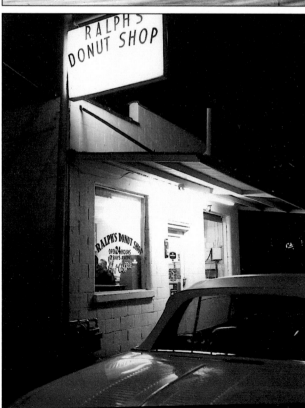

Ralph's Donut Shop, open 24 hours, has been a longtime favorite with students and faculty. Serving only assorted kinds of donuts and coffee, the shop only became less popular in the 1990s because of competition.

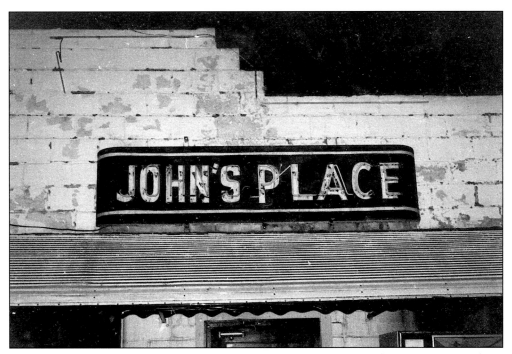

John's Place on U.S. 70 west of town at the "triangle" was one of the few places that students could drink beer in the 1950s–1970s.

John's was one of the few integrated restaurants in the 1950s and early 1960s. Owned by the McClellan family, both blacks and whites were welcome.

Games, music, hotdogs, and beer were all enjoyed by Tech students at John's from the 1950s through the 1990s. John's became less popular in the late 1990s because of the emergence of chain restaurants and bars near Interstate 40.

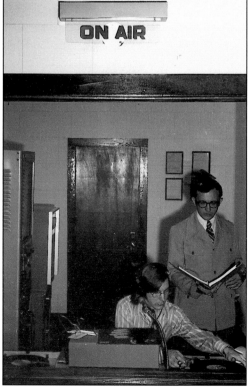

WTTU, the student radio station, received its license to broadcast in 1972, and it went on the air in May at 88.5 FM. Don Caldwell was the first station manager. The programs featured easy listening, pop music, contemporary jazz, and hard rock.

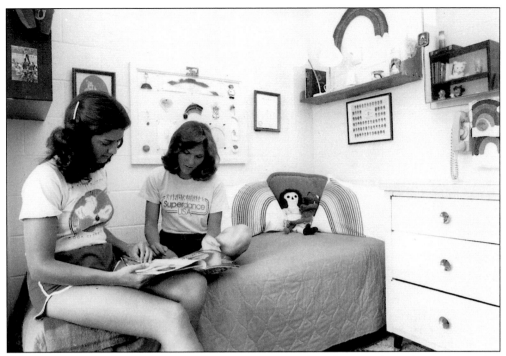

Vickie Carrol, cheerleader and head resident at Murphy Hall, right, consults with a student in her dorm room in 1982. By this time, student rooms had televisions and telephones.

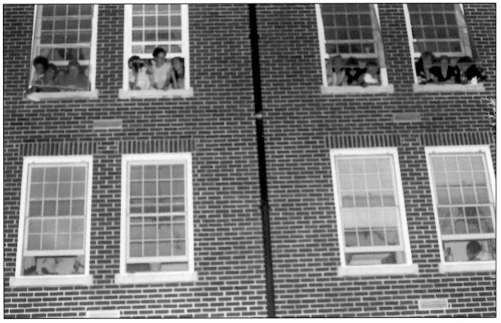

Panty raids—male students taking lingerie from the women's dorms—were popular at Tech in the 1950s and 1960s. In four different years—1952, 1959, 1963, and 1968—Tech boys made such assaults on the girls' residences.

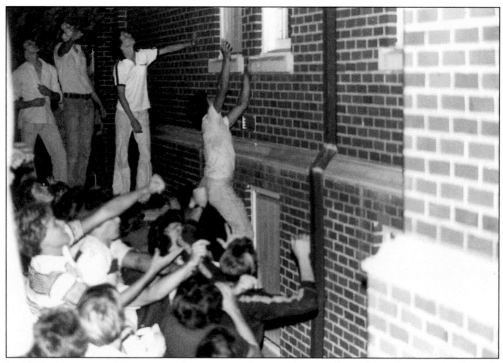

In 1952, the panty raids were met by taunts and water showers from the girls. In 1968, the girls actually threw their panties out of the windows to the raiders.

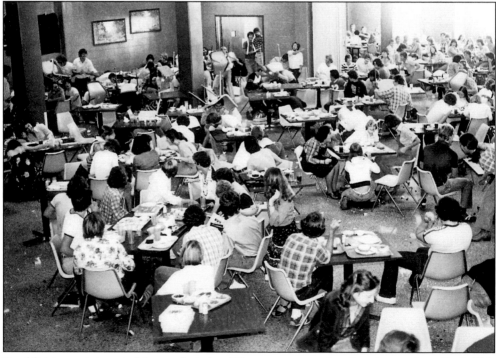

Food fights, reminiscent of the movie *Animal House*, were occasional student antics at Tech. This one in 1978 in Roaden University Center created a big mess for the maintenance crews.

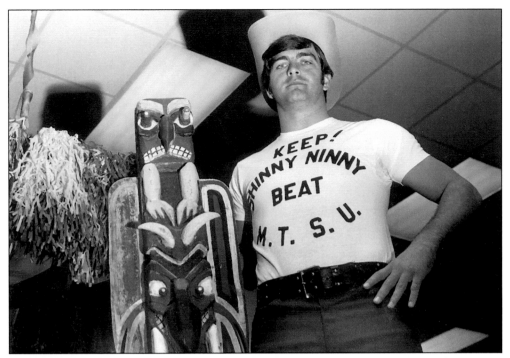

Shinny Ninny, a wooden Indian totem, was a gift from Nashville businessman Fred Harvey in 1960. It is given annually to the winner of the TTU-MTSU football game. Occasionally, one of the schools would "steal" the totem from the other. MTSU calls the totem "Harvey."

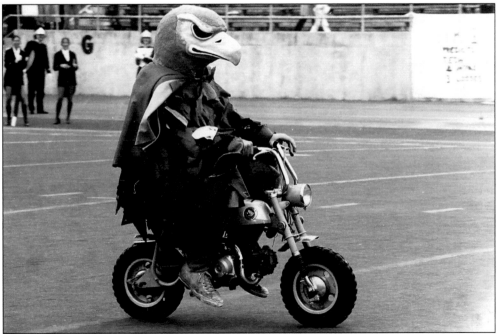

The golden eagle has been Tech's official mascot since 1925. Awesome Eagle, a student dressed as the bird, is the actual mascot who performs at athletic contests. It is considered an honor to be chosen Awesome Eagle.

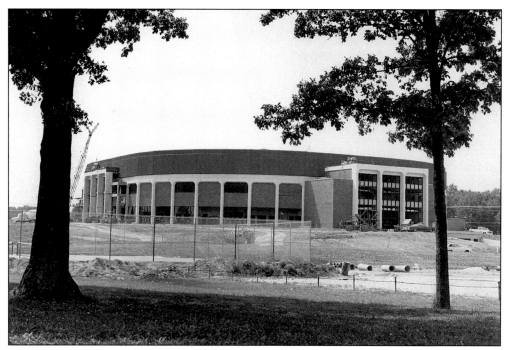

Hooper-Eblen Center, seating 10,150 people, replaced Memorial Gym as Tech's basketball arena and auditorium in 1977. It was named for Tech's athletic director who died of a heart attack in 1976. The student nickname for the arena is "The Hoop."

"The Blizzard," a storm of paper thrown by students when Tech scored its first points in a basketball game, started in 1985. Conference athletic officials were upset by the practice, and the game referees threatened to penalize Tech teams for the fans' display. The NCAA banned this practice in 1986.

118

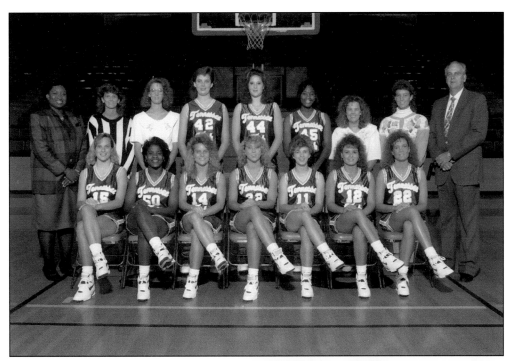

In 1992, Coach Bill Worrell, standing right, was OVC Coach of the Year. After the 1993 season, the Eaglettes had captured five consecutive OVC championships. On the left is coach Myra Fishback. Rochelle Vaughn (50) and Dana Bilyeau were All-OVC in 1993.

Coach Tom Deaton's 1985 Golden Eagles won the OVC championship, which marked the first time they had sole possession of the title in 27 years. Stephen Kite (23) was OVC Player of the Year. Deaton was OVC Coach of the Year.

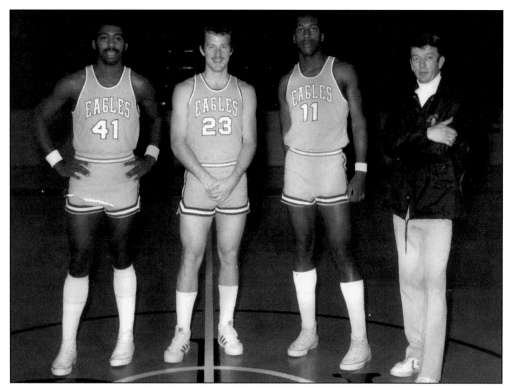

These 1977–1978 players are Butch Blaylock, Dennis Godfrey, Marc Burnett, and Coach Bill Malpass. Burnett was team captain for five years. Blaylock later played professional basketball and Burnett became vice president for student affairs at Tech. This team defeated Vanderbilt University 72-71 in the dedication game at the Hooper Eblen Center.

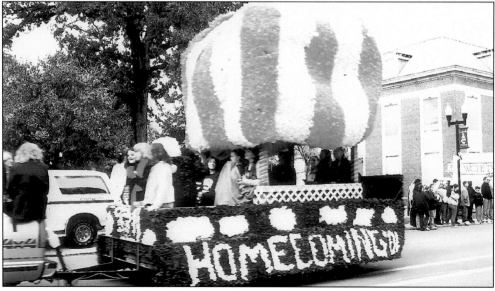

Homecoming is one of the oldest traditions at Tech, beginning on Thanksgiving Day 1928. The parade, with floats and bands, is a highlight of the occasion, along with class reunions and the football game. This float was part of the 2001 Homecoming parade on Dixie Avenue.

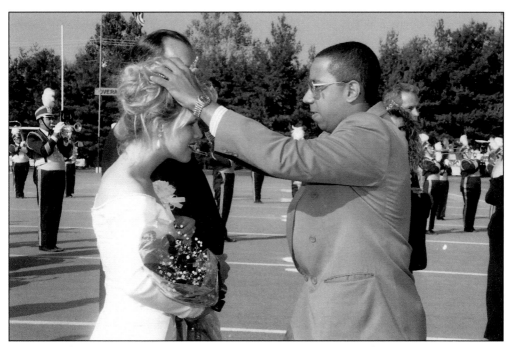

Selection of the Homecoming Queen, and her presentation at the football game, is another highlight of the celebration. Allison Gore, sponsored by Pi Kappa Alpha, was crowned queen in 1992 by SGA President Nathan Burton.

Around 1970, Tech's football program recruited some outstanding individual players. Larry Scheiber, a tailback, was All-American in 1969, gaining a record 4,421 yards during his career. Jim Youngblood, pictured here, was All-American lineman in 1970. Both later played professionally.

Tech's 1975 football team compiled an 8-3 record to share the OVC title with Western Kentucky. Don Wade was head coach of the Golden Eagles during this time.

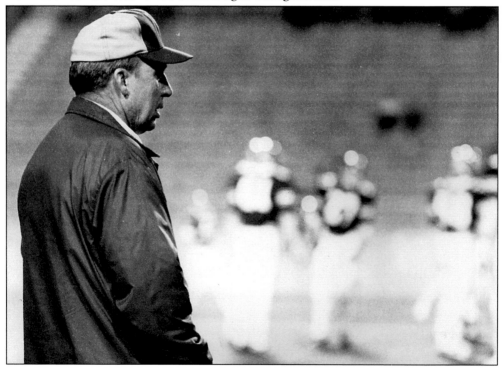

Football coach Don Wade came to Tech in 1968. He was named OVC Coach of the Year three times and his team won the conference championship twice. He retired in 1982.

Quarterback Grant Swallows led Tech to an exciting football season in 2001. With an overall team record of 8-3, Swallows set three school records. His total yardage was 4,605. He became the all-time passing leader and the single season passing leader. Tech's team was number 23 in the national rankings at the end of the season.

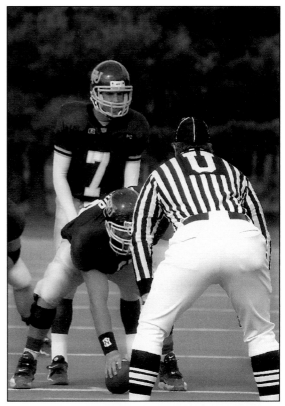

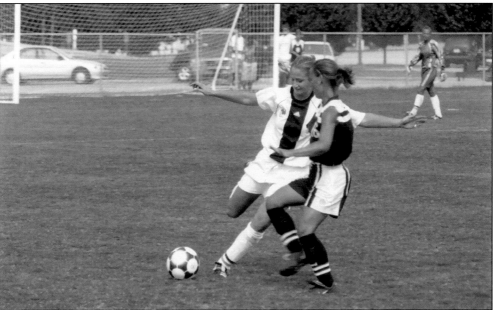

Tech soccer gained a new field next to Hooper Eblen Center in 2000, and Tech's women soccer team won the OVC championship. Twenty wins brought them a trip to the NCAA playoffs. The team set records for most goals, most points, and most shutouts. Greg Stone was the new coach that year.

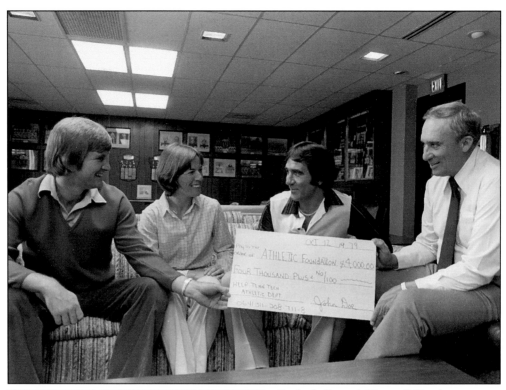

Basketball coach Marynell Meadors, Athletic Foundation director Jim Ragland, and football coach Don Wade proudly exhibit a check to the new Athletic Foundation in 1979.

Coach Mike Hennigan attended Tech and played on the 1972 championship team. After graduating, he played for the Detroit Lions and the New York Jets. In 1986 he returned to Tech as defensive coordinator, and in 1995 he succeeded Jim Ragland as head coach.

Jeff Lebo replaced Frank Harrell as head basketball coach in 1998. Captain of Dean Smith's University of North Carolina team, Lebo was later assistant coach at the University of South Carolina. In his second year at Tech, Lebo's Golden Eagles won the OVC Championship with a 20-9 season record. They repeated as OVC champions in 2002.

Tech's international students, 178 people from nearly 20 countries in 2001, comprise an important part of Tech's student body. A number of faculty members also hail from other countries. Most Tech students are Tennessee residents and meeting individuals from other cultures is an important part of their education.

Gloria Anderson, longtime custodian in Roaden University Center, typifies the maintenance staff at TTU. Highly skilled and dedicated, these 150 women and men keep the university running.

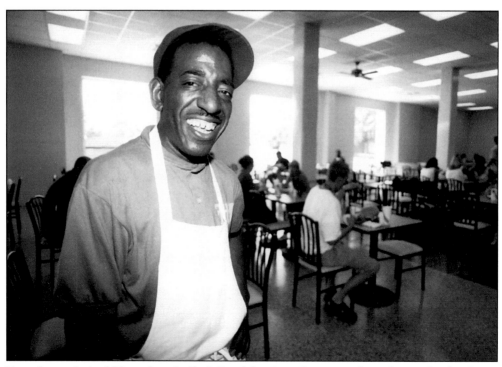

Tony Savage is 1 of 50 workers in Tech Food Services. Operating the cafeteria, faculty dining room, Swoop Grill, and banquet catering, this staff serves a quality product at reasonable prices.

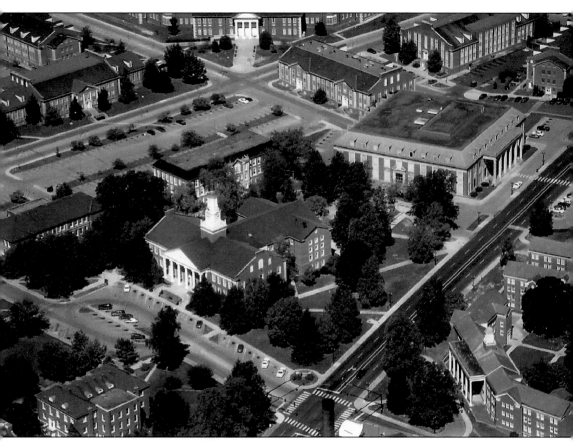

Derryberry Hall, at the center of this photo, was the first building on the campus. As this photo shows, it is still the center of campus buildings and campus activity.

Building a campus, building character, and building careers has been the story of Tennessee Tech. It is the hope of the authors that this book has illustrated those ideas in an instructive and entertaining manner.